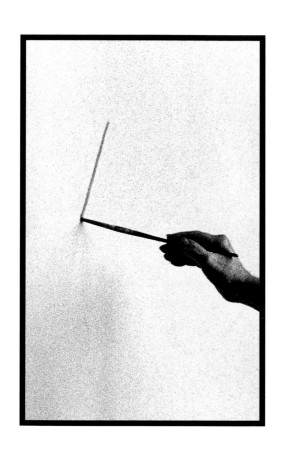

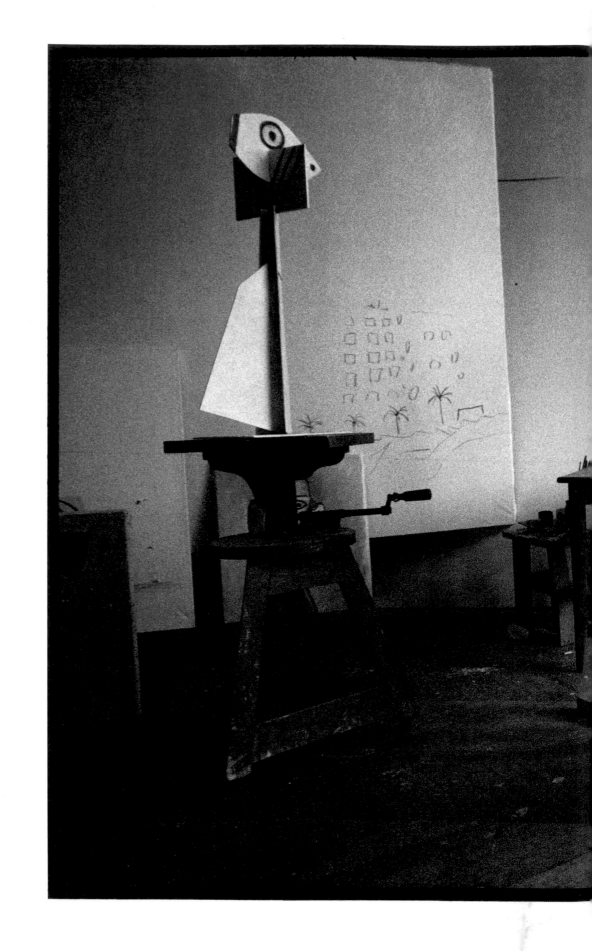

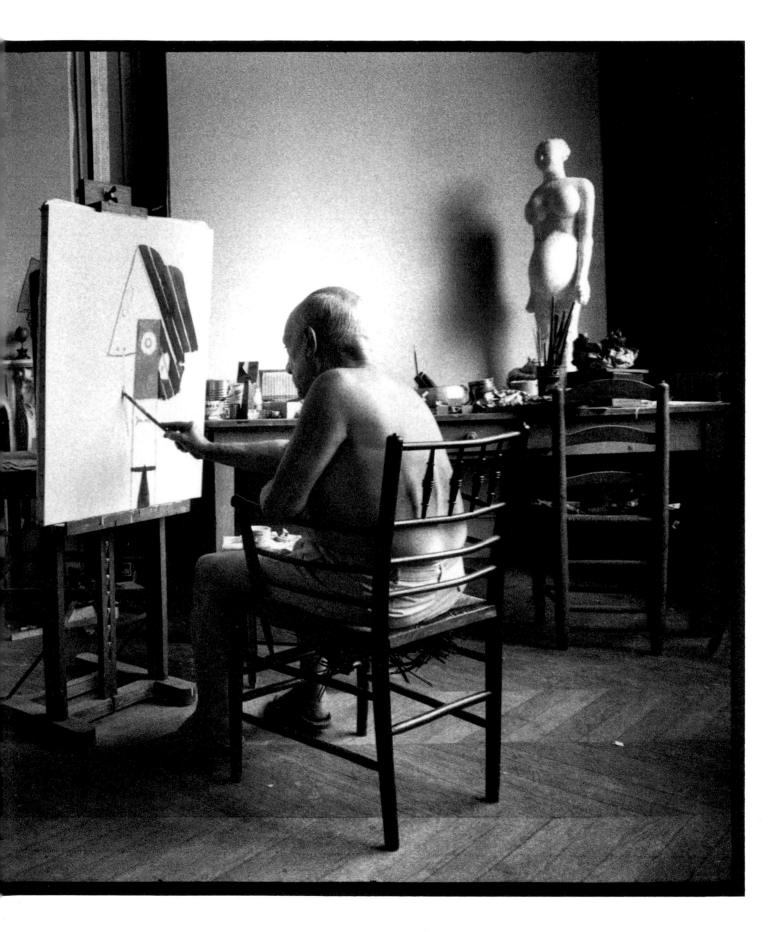

# Picasso Paints
# a Portrait

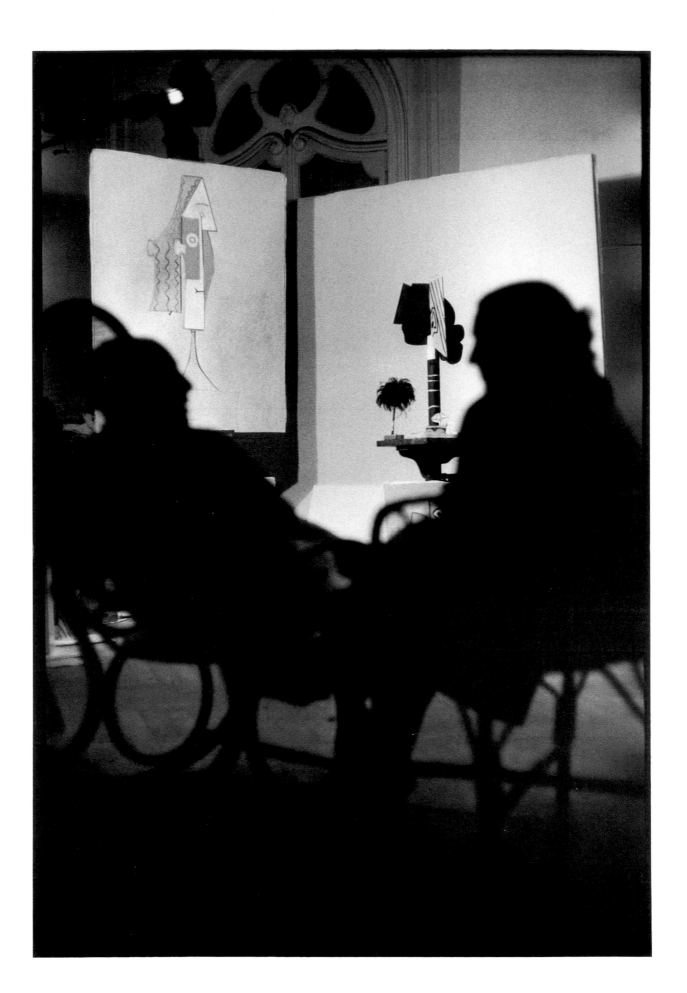

DAVID DOUGLAS DUNCAN

# Picasso Paints a Portrait

With 65 duotone photographs

THAMES AND HUDSON

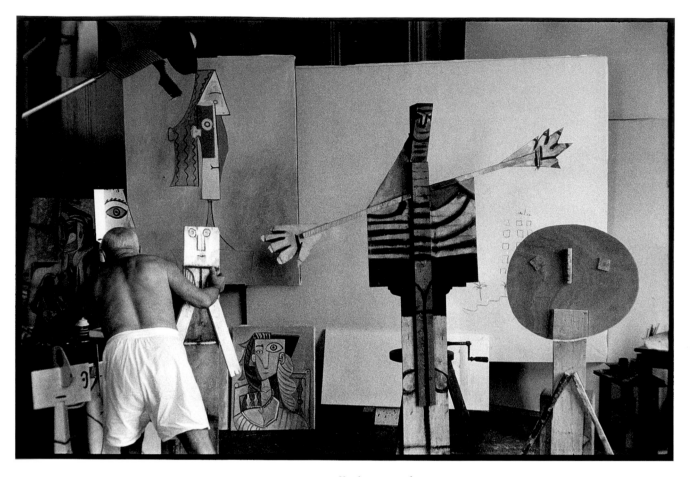

Permission all photographs
Pablo Picasso
© Succession Picasso 1996

First Published in Great Britain in 1996 by Thames and Hudson Ltd, London

Copyright © 1958/1996 David Douglas Duncan

British Library Cataloguing-in-publication Data

A catalogue record of this book is available from the British Library

ISBN 0-500-23722-0

Master Exhibition Prints
John Downey - Heike Hinsch - Lutgardo Rodriguez
Time-Life Photo Laboratories, New York

Composition by Franck Follet

Design and Production by David Douglas Duncan

Printed and bound in Italy by Arnoldo Mondadori Editore, Verona

# Memories

*Page 1:* The elegance of Picasso's hand with a paintbrush protruding from extended fingers — fragile antenna on a weightlifter's body — set him apart from all men I have ever known.

*Page 6:* Sculpture combines risk with imagination to create a new reality from many often disparate materials — here sheet metal. In this flanged silhouette of Jacqueline, her classic profile proved its veracity as she enjoyed a midnight workbreak with Picasso at Villa La Californie, their 1957 home in France above Cannes. She was *the* inspiration of his later years.

*Page 8:* One small corner — and a fraction of just one summer's work — in La Californie. Picasso partially cleared additional space for a new project . . . another portrait of Jacqueline. Paintings, flanged sculptures, and wooden maquettes of his then still-unknown *Bathers of La Garoupe* suddenly were all shoved aside leaving one end of the studio uncluttered. It was midsummer and Picasso often appeared in underwear shorts or swimming trunks, to work in comfort. La Californie was closed to all outsiders for days upon end — a forbidden, painter's paradise.

*Page 11:* When preparing to paint, Pablo Picasso — a meticulous craftsman whose work sometimes gives the appearance of casual conception — in no way gave the impression of being this century's most influential and renowned artist: Texas-handcarved-leather belt; swimming trunks atop pile-driver legs which seemed rooted in the floor; his Atlas' shoulders supporting a cannonball head that was crowned with a circus clown's derby worn for a moment only because it was nearby. His cavernous studio offered sanctuary to a serene young neighbor, *Expectant Mother*, later immortalized in bronze. He was also the host of two elderly garden snails living in a cage under the left elbow of a painter cleaning each of his brushes — getting ready to work.

*Pages 12-13:* Villa La Californie, summertime, 1957: variations on *Jacqueline* everywhere. (Left); Charcoal on canvas and collage of wrapping paper and ribbon from a gift box of deluxe chocolates, brought by Swiss art-dealer friends Siegfried and Angela Rosengart (13 February, 1957). (Center-to-right); Oils on canvas and metal-flanged sculptures, all 1957 and all of Jacqueline. The broken, cane-seated chairs were cherished favorites that had followed Picasso each time he moved into another studio-home. Never repaired!

*Pages 14-17:* Picasso ready to paint, encircled by earlier portraits of Jacqueline and a pair of charcoal-on-paper souvenirs for Daniel-Henry Kahnweiler, his famed — legendary — art dealer. Their friendship predated the birth of Cubism in Paris, from the beginning of the 20th century. *(Page 12):* When Picasso raised his arms to adjust canvas to easel, it seemed as though I'd become witness to an act of religious devotion . . . or crucifixion . . . until that unexpectedly sublime hand swept down across the canvas and he began painting. Nothing else had moved.

*Page 19:* That single slash of black brought life enough to a canvas to alone justify itself — to me. I remembered, too, a monolithic diorite Pharaoh — also bare-chested — in Egypt's colossal archaeological museum: Chephren, who ruled the Nile Valley nearly five thousand years ago — and built the Great Pyramid of Giza. And I wondered how long this modern Pharaoh's name and work would be remembered, beckoning to other strangers of faraway tomorrows.

*Pages 20-43:* Always before, during more than that first year of our friendship, I'd already put away cameras and left when he began to paint. We had "met" one February morning in 1956. I was then en route from Afghanistan (long before the heartbreak and destruction) to Morocco. He was in a bathtub at La Californie. I gave him a carnelian ring, engraved with a tiny Picassoesque rooster by an unknown — perhaps Greek — artist around the time of Jesus' Flight to Egypt. The origin of *that* ring is another adventure tale from my roaming-camera days in Central Asia.

But this time, he had looked straight into my lens' eyes — and returned to locking canvas to easel . . . I just kept shooting. From this moment, my cameras and I vanished through the gate of his almost monastic inner world. My custom-built M3D Leicas featured supersilent shutters. That was long before the invention of zoom lenses, so common today. The Picasso seen here at arm's length was photographed at arm's length — a man seemingly isolated and insulated within the magnetic field of his own creativity. Perhaps I generated no more "presence" than Lump, the dachshund, who wandered freely between garden and studio no matter what was on the easel. Meanwhile, Picasso created one version after another of *Jacqueline*, stroke by sure stroke. And yet, maybe he was not *that* certain while journeying on imaginary roads to elusive destinations — and possibly even a little disappointed after he finally arrived — with still another mirage already smiling and waving to him from the always receding horizon.

*Pages 44-45:* "Stop! . . . STOP!" . . . my heart and eyes were *shouting*. He never heard us! We saw him destroy *Zebra Jacqueline* . . . from one arm's length. And we couldn't — didn't — lift even one little finger to save her. Stand between them! Drop the cameras! Or do anything — until too late. She disappeared almost as quickly as she had arrived that same afternoon. Hers was a face seen only once in a seething crowd. Then gone. And this *really* was forever! Even in a multitude one might have dreamed of a sudden miracle — but not here . . . . Picasso kept painting, I kept shooting. Even now, almost forty years later, I'm still in love.

*Pages 46-61:* For much of two days and nights, Pablo Picasso and I stood side-by-side, telling our own wordless stories. Apparently it had not happened before with him, surely not with me. And never happened again. He began to paint just after midday on the first of July and stopped just before dawn, 3 July, 1957. Jacqueline had long gone to sleep upstairs when he gouged a deep furrow into his paint, then washed every brush — and flicked off the studio lights. Another *Jacqueline* now dominated his easel and the fading night.

*Pages 62-71:* Around noon, the following day, Picasso and Jacqueline silently appraised the new portrait. I then made the lone photograph in that home which fused into a single person two remote people who had opened their always-closed private life to a stranger. With magical luck, this double portrait paraphrased his 1930s images of *The Old Minotaur King and Maiden* — with their mystery and dignity and absolute love for each other surviving intact. By midafternoon he had curled into his old chair, and laughed: "Duncan . . . it's much easier to start than stop!" That night — only by moving his chair — he began another journey to an imaginary world.

*Postscript:* The final version of *Jacqueline* is today in a private Swedish collection.

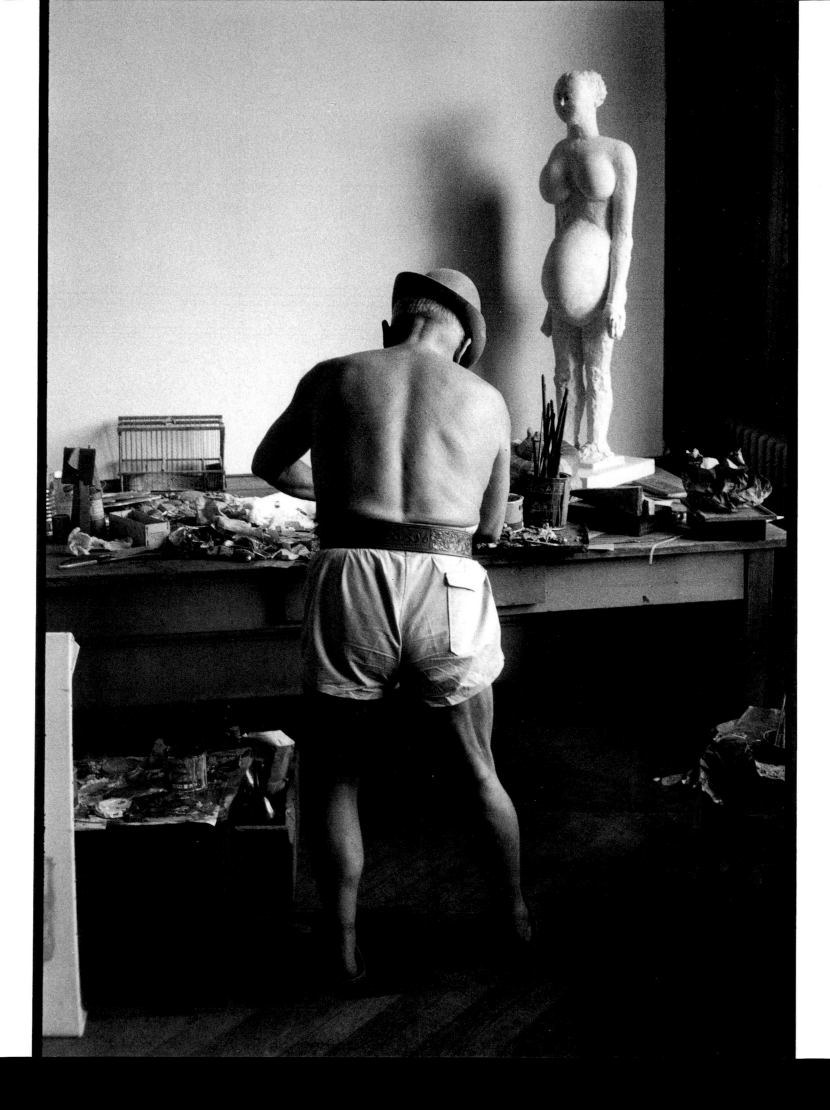

48 Hours

# Summer
# 1957

Alone with Picasso
and Jacqueline

*Painting Her Portrait*

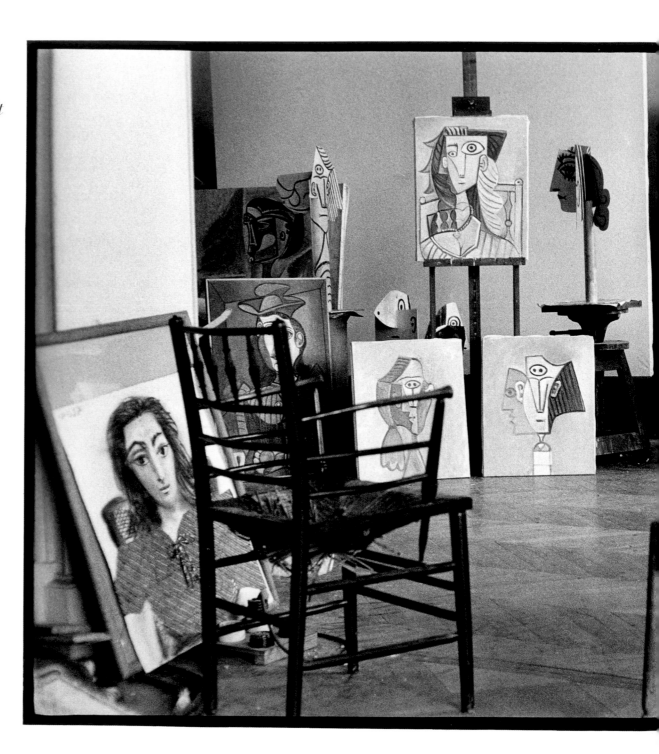

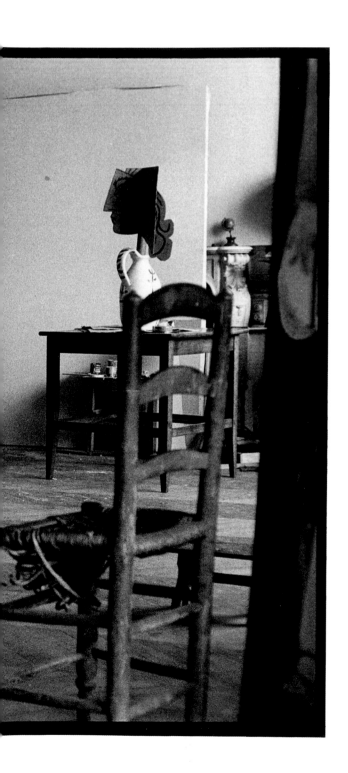

*It was the silence . . . and that hand*
*I'll always remember.*

*His right hand suspended in space against canvas,*
*like that other hand reaching forever across Heaven.*
*Above all of those upturned faces far below.*

Of course, I thought of Michelangelo, of the Sistine
Chapel ceiling, and his Hand of God the Creator.
But *this* hand I'd seen daily — close up. Slender and
elegant, except for the pigeon-egg muscle between
thumb and forefinger when he casually bent sheet-
metal flanges into profile portraits of Jacqueline.
Whom he was now painting with slashing strokes,
black-and-white, while I photographed at his side.
For most of two days and two nights. Until he'd
abruptly stopped.

We barely exchanged one word.

The next morning, he laughed, and said . . .
"Duncan . . . it's much easier to start than stop."

And somewhere back along the way, he'd created a
masterwork of slanting lightning bolts blazing down
from a midnight sky — unlike any Picasso to be seen
before, or ever again. For suddenly that magical storm
veered away into the night and another *Jacqueline*
was now on his easel when he flipped off the lights.
Jacqueline, herself, had long ago gone to bed.
It was nearly dawn and he was nearly seventy-seven,
at the end of one more normal day.

But for much of the following day, he just sat quietly
in his favorite old rocking chair staring at the floor
. . . at something I could never see.

Then, that night, he began to paint.

Again.

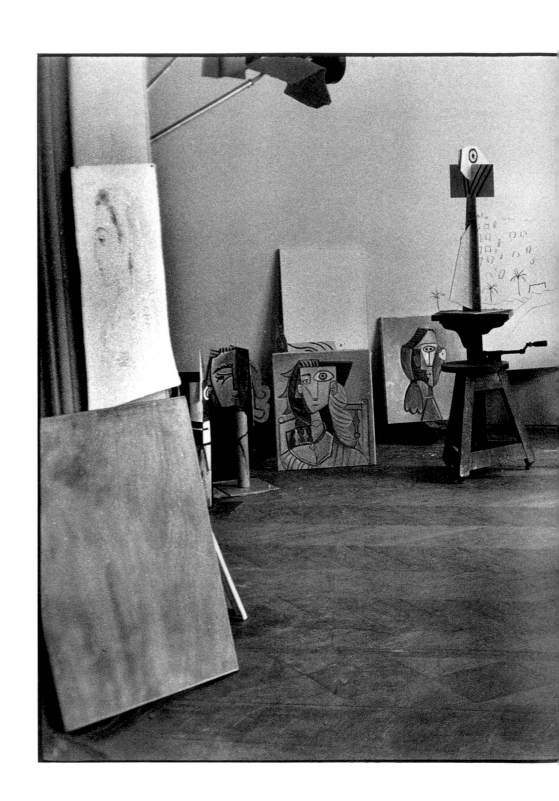

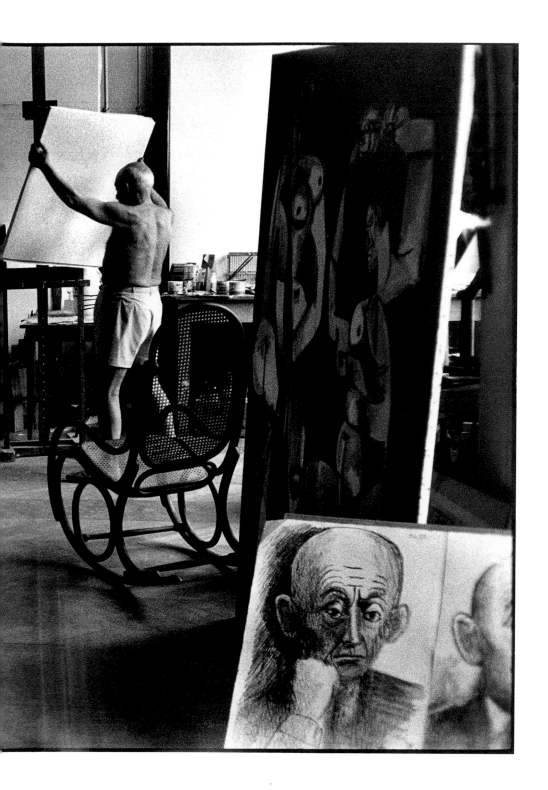

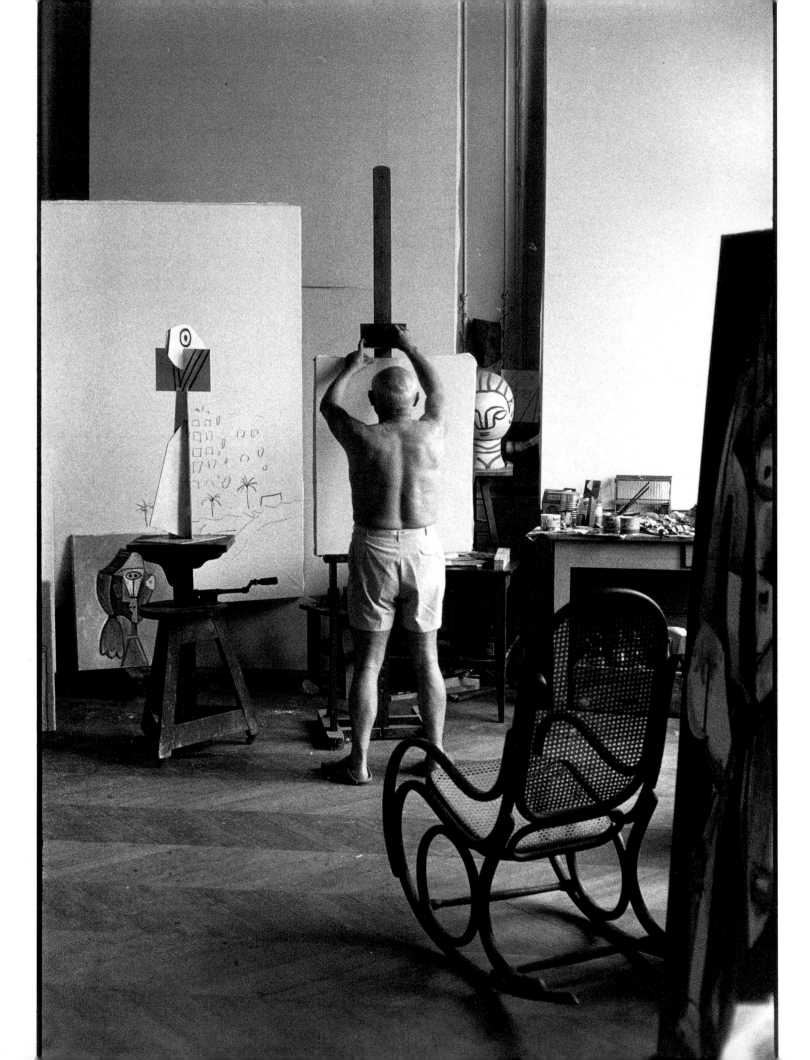

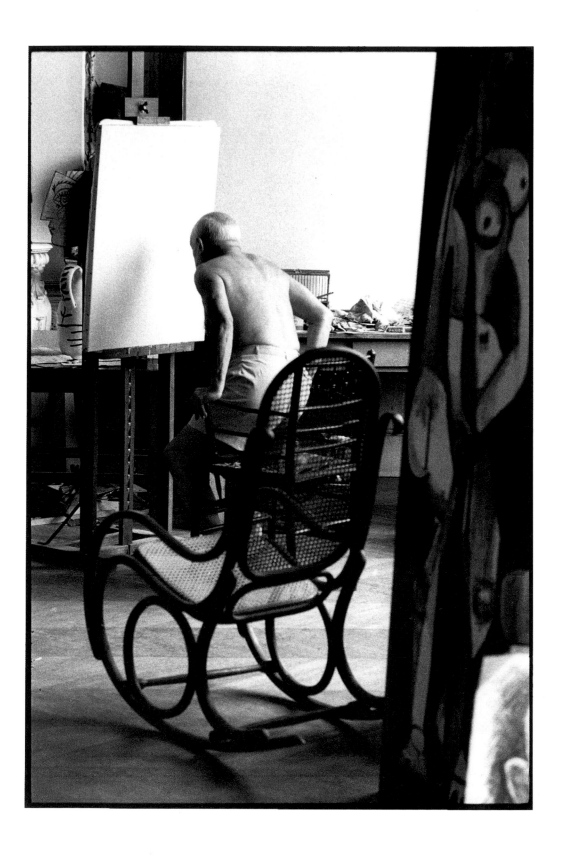

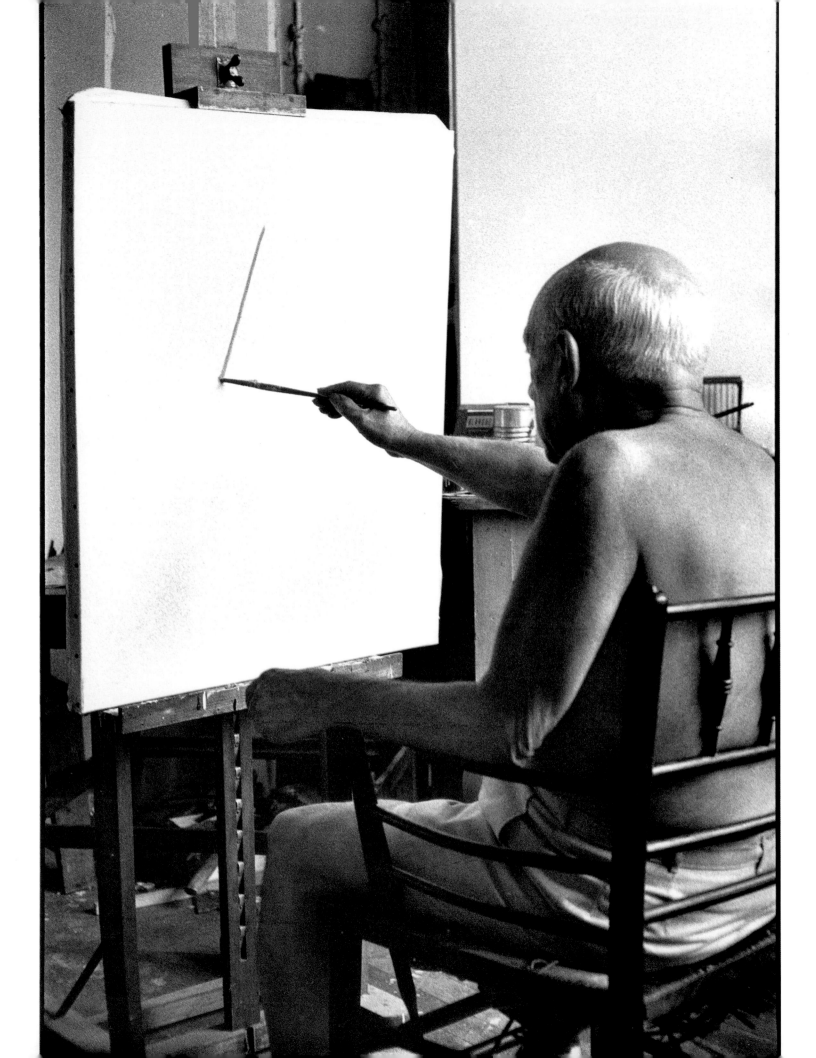

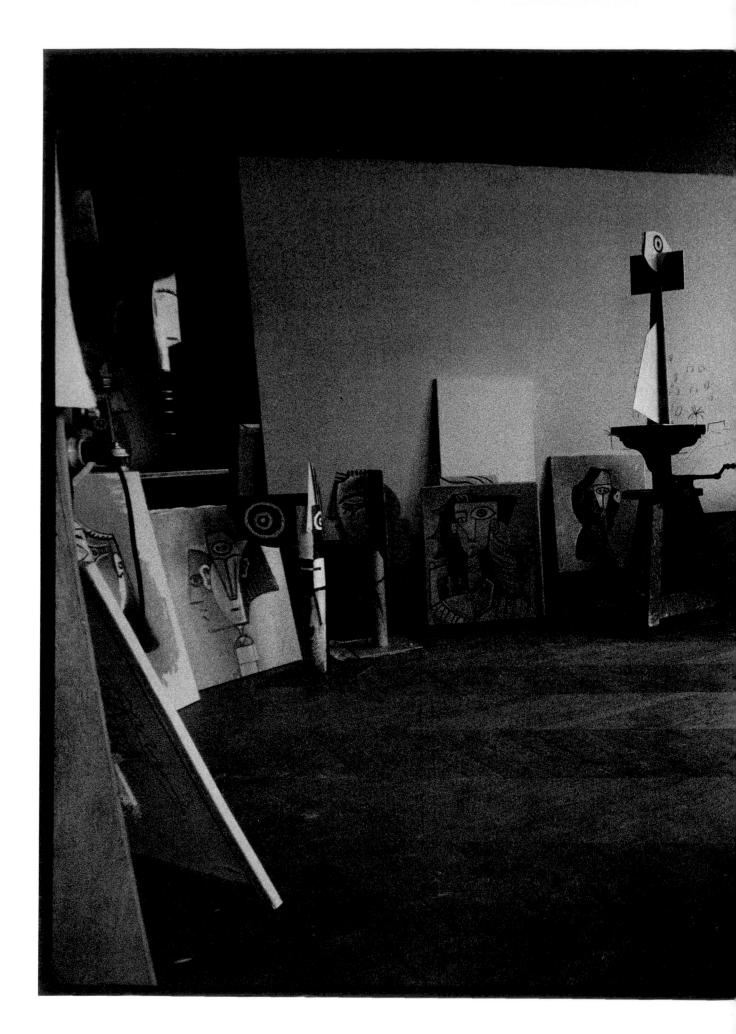

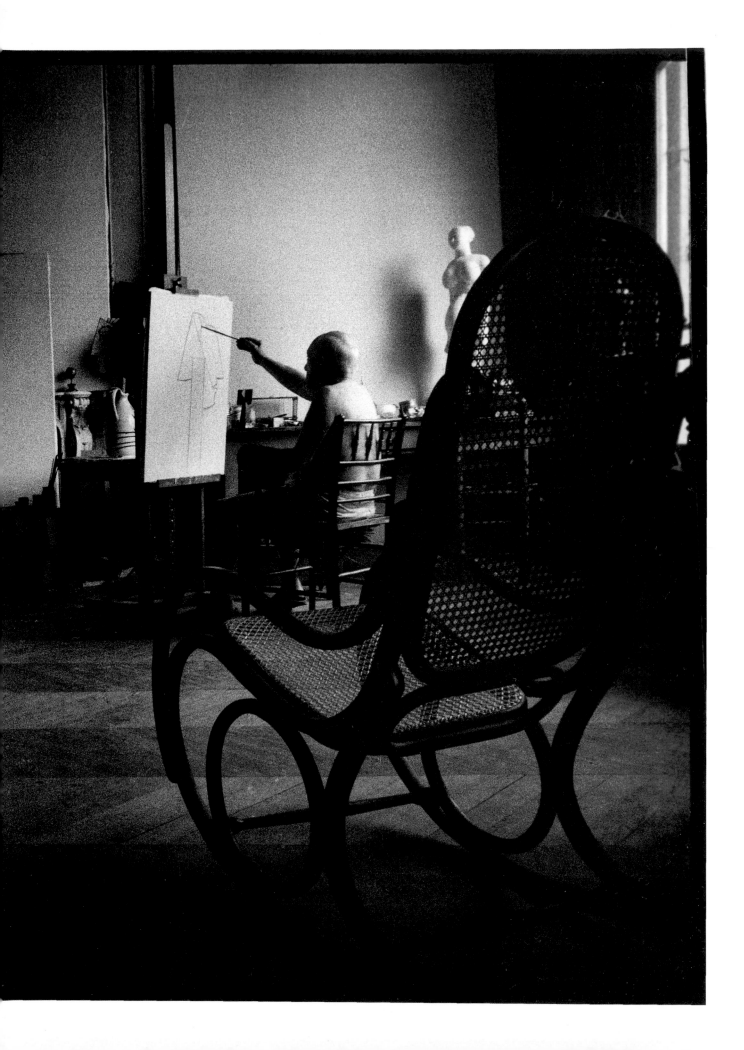

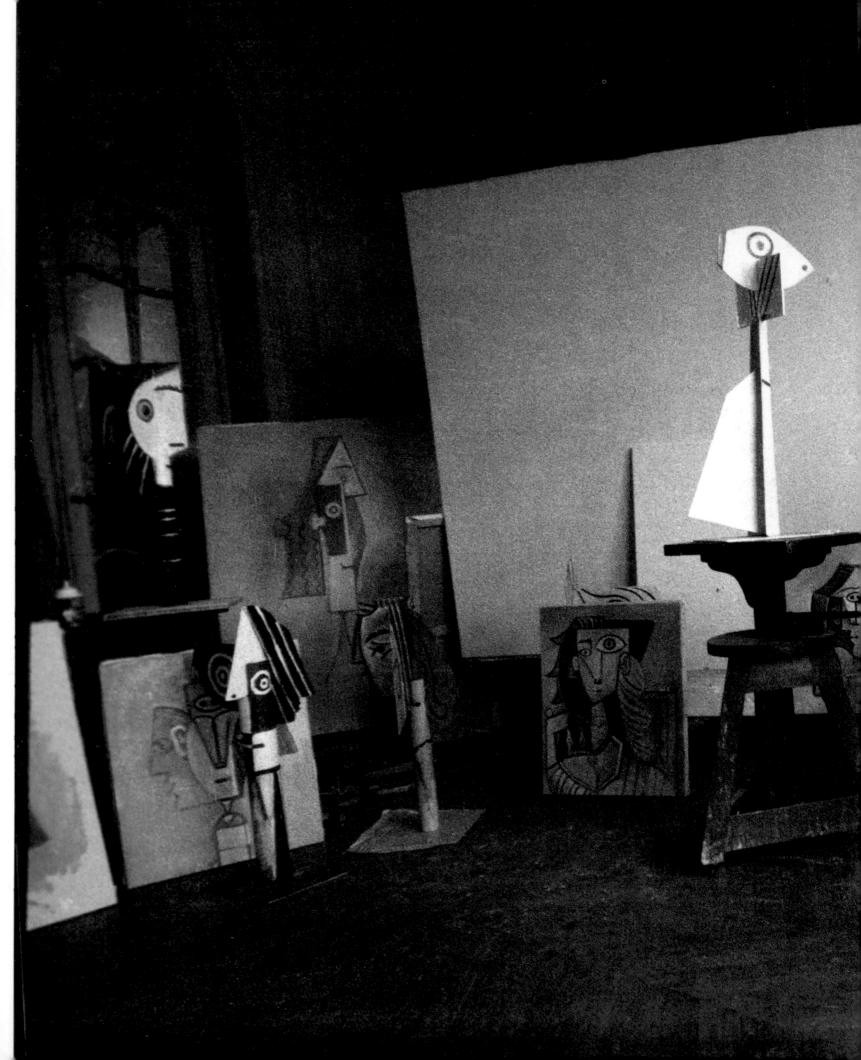

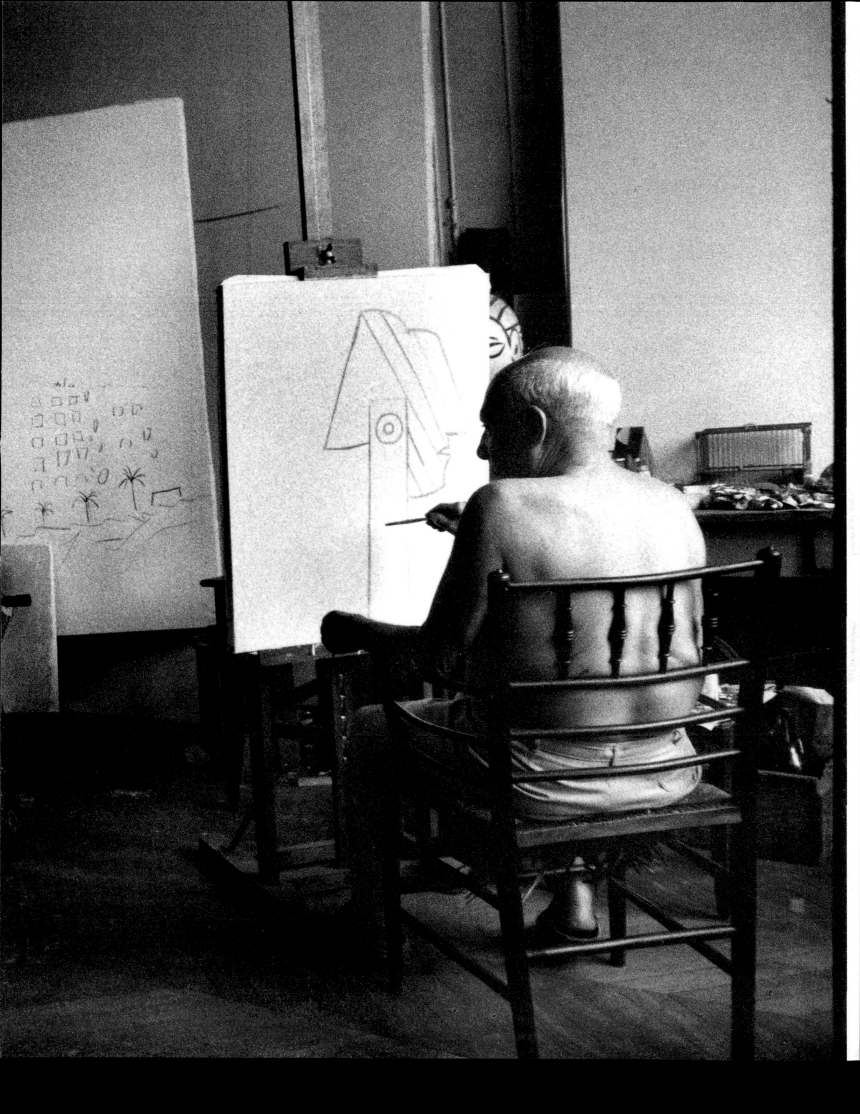

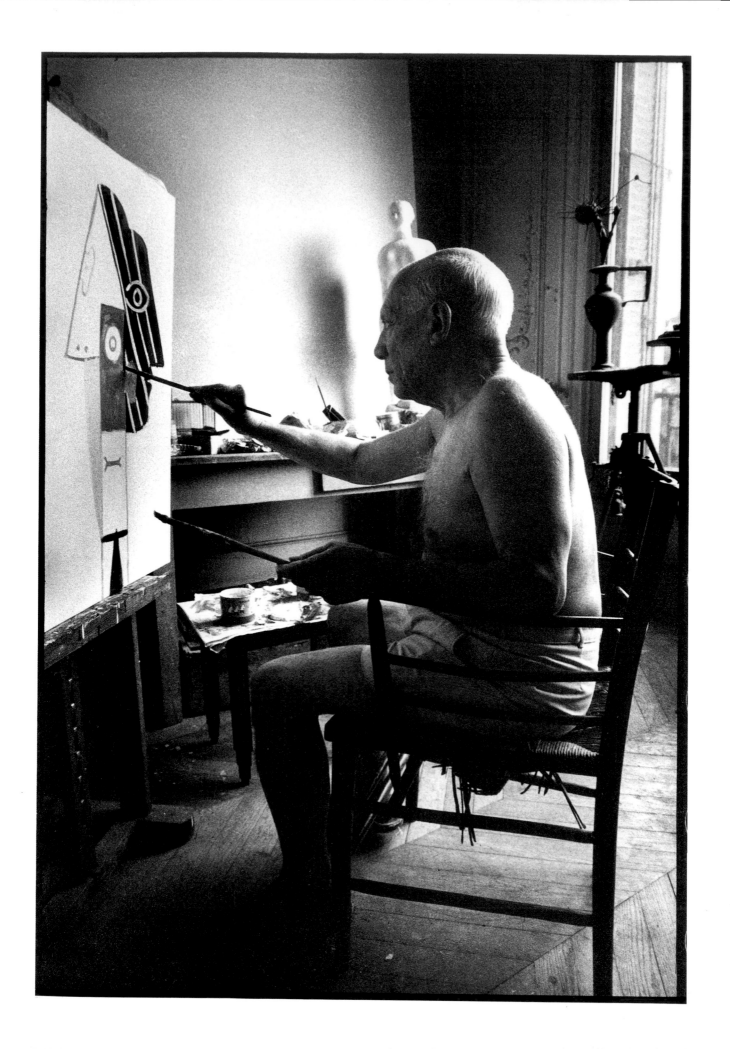

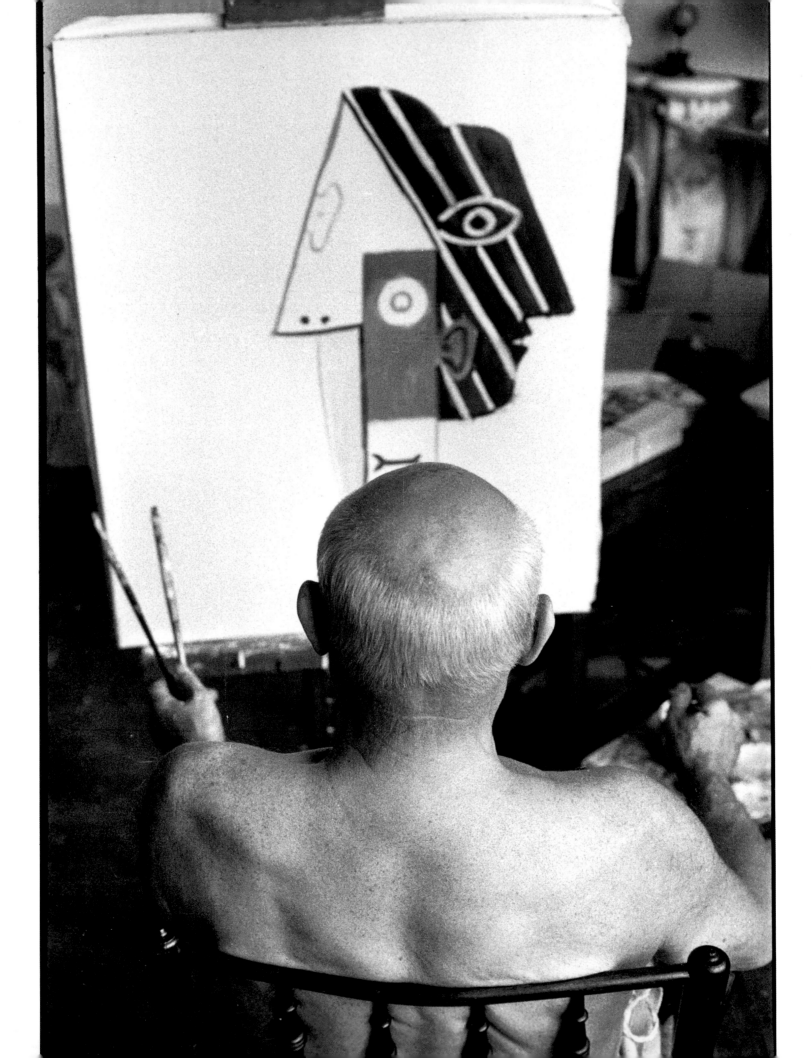

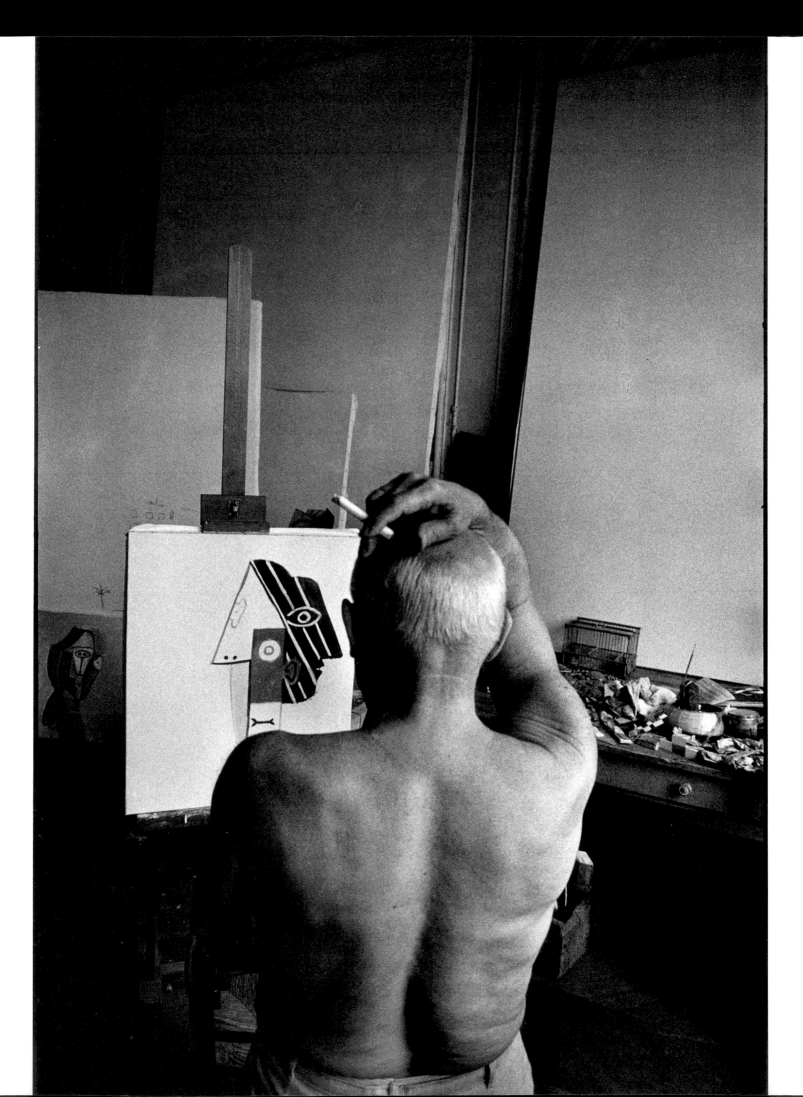

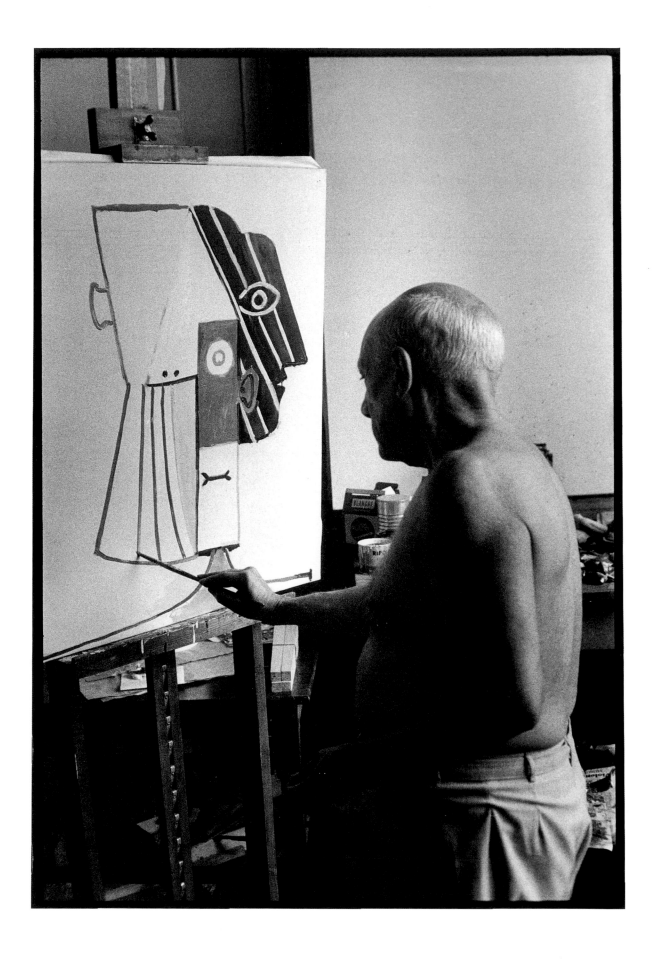

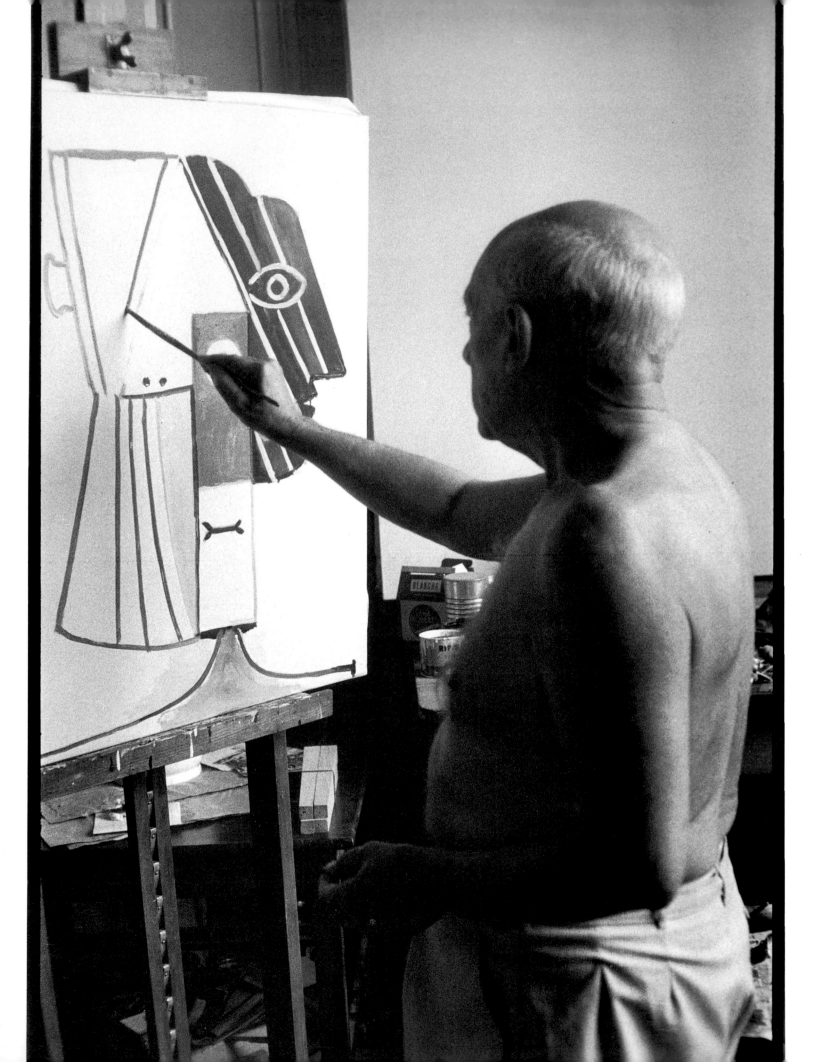

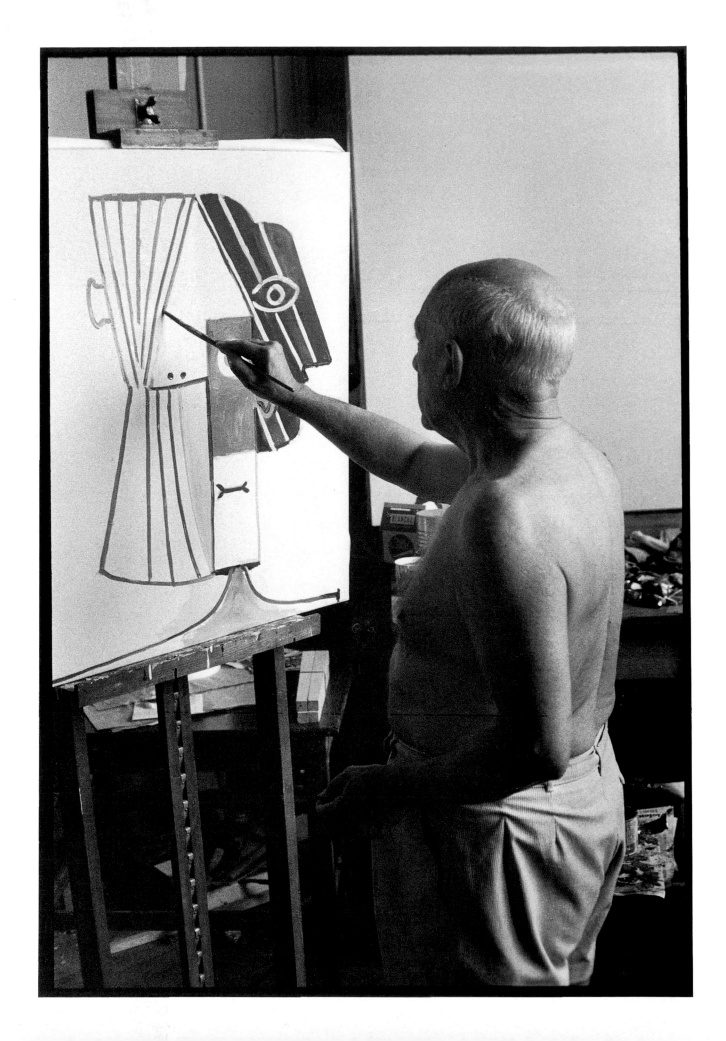

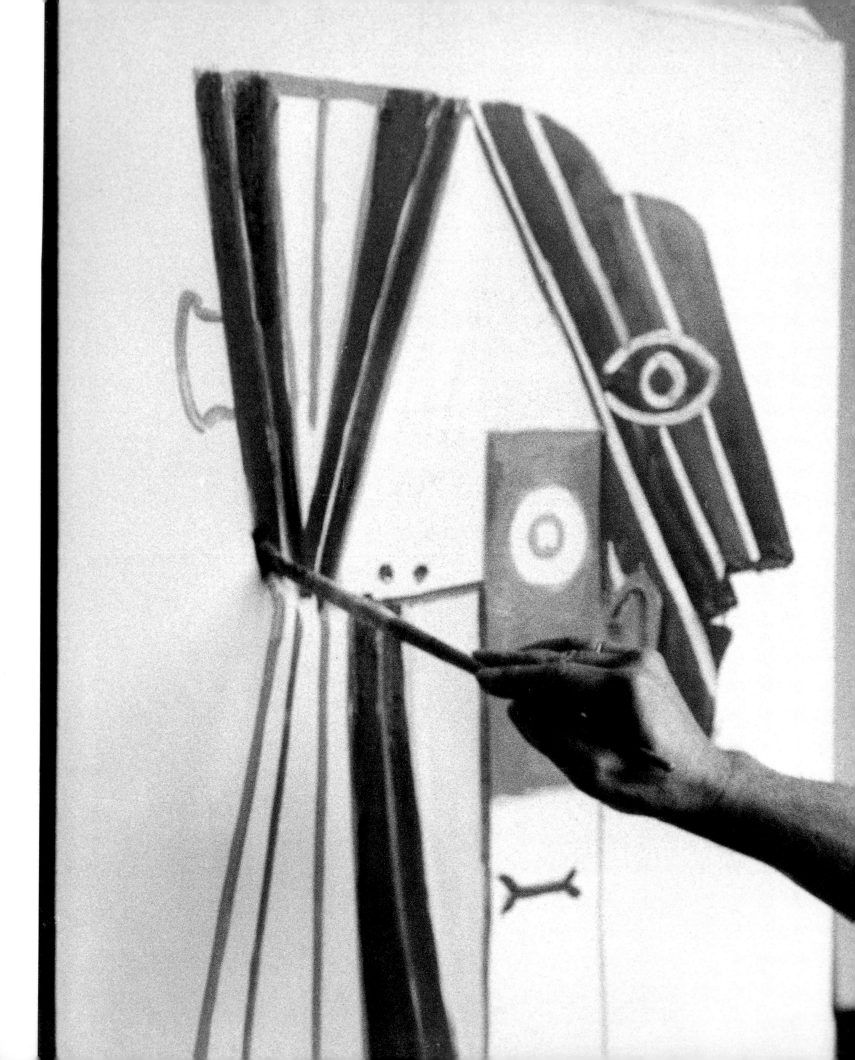

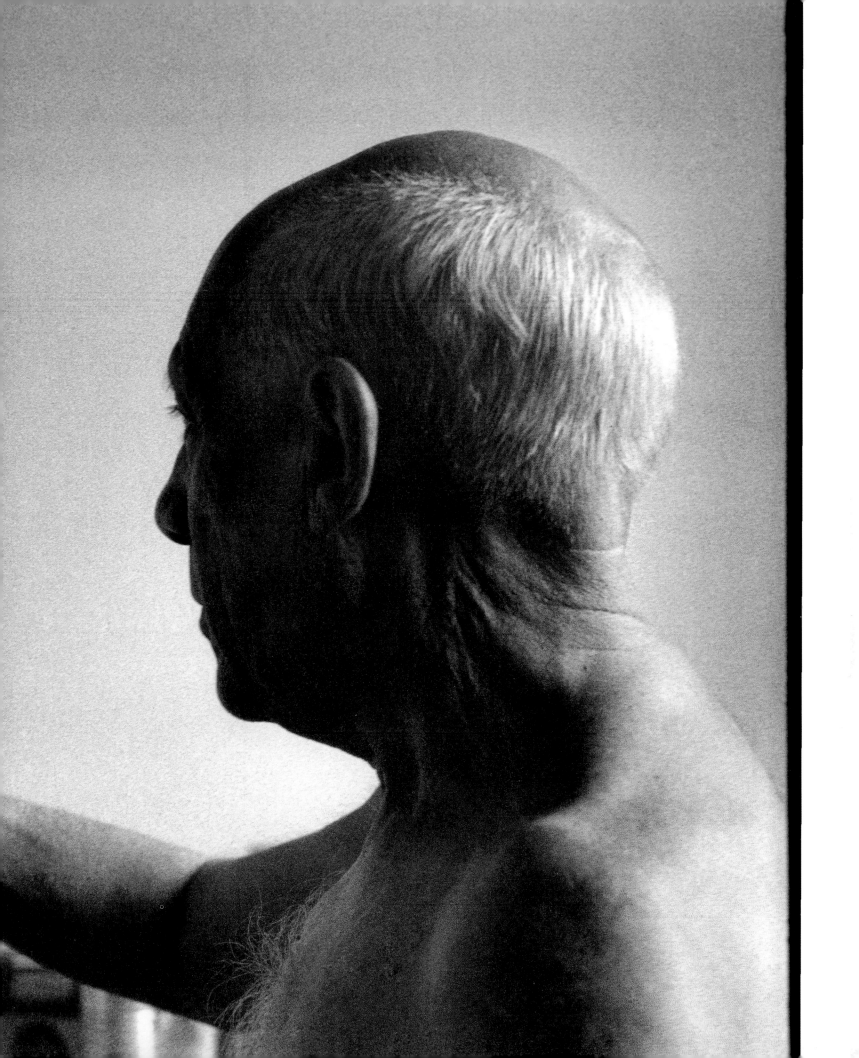

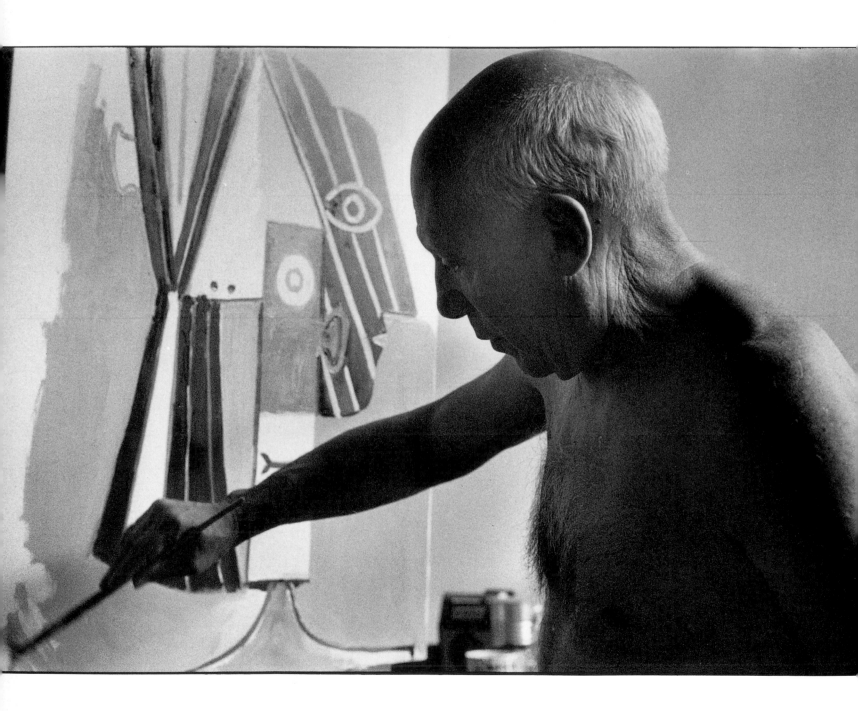

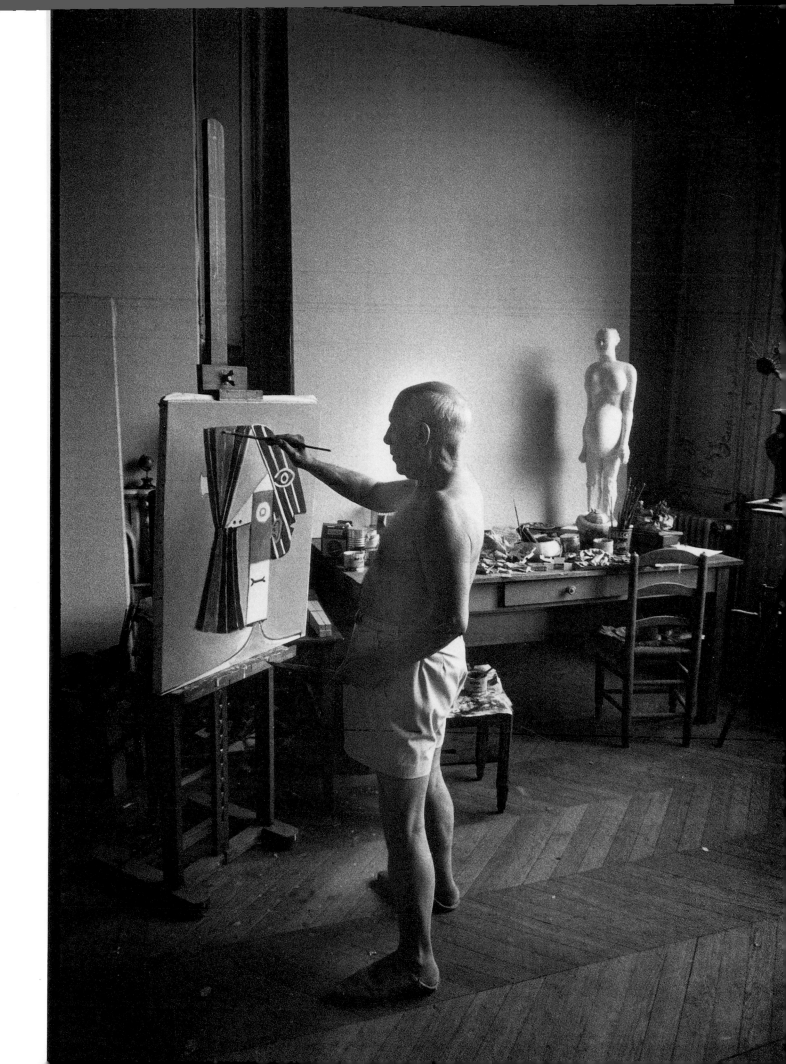

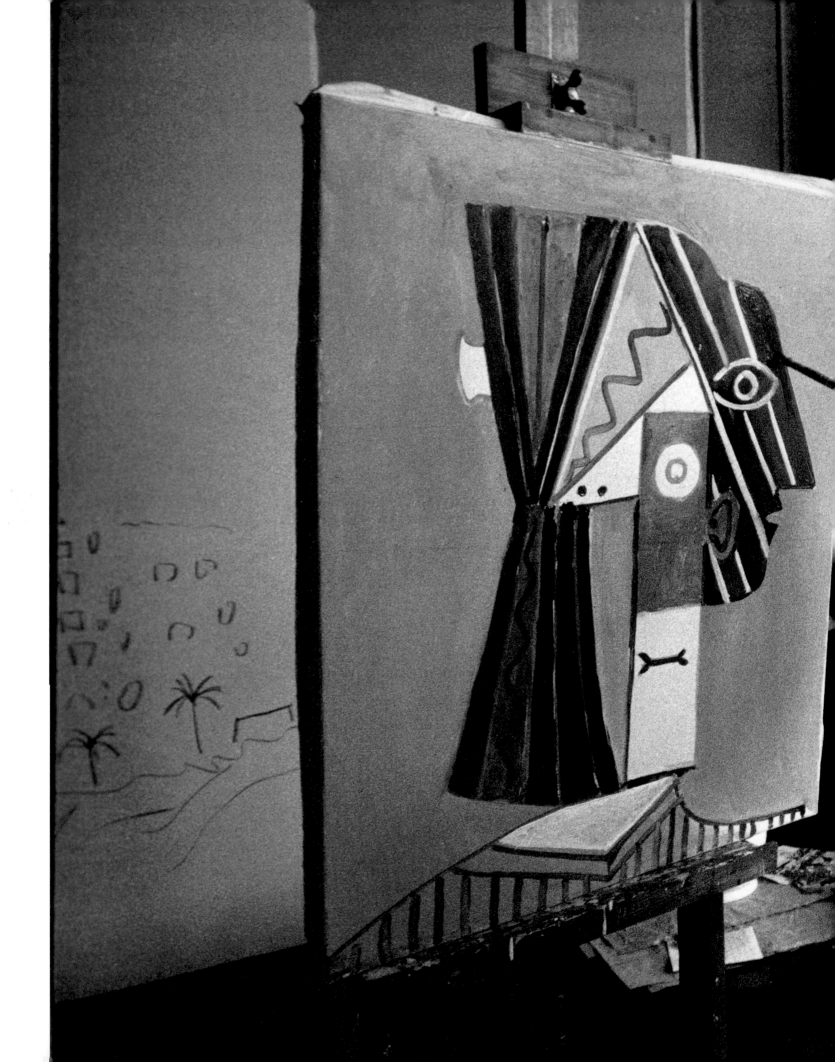

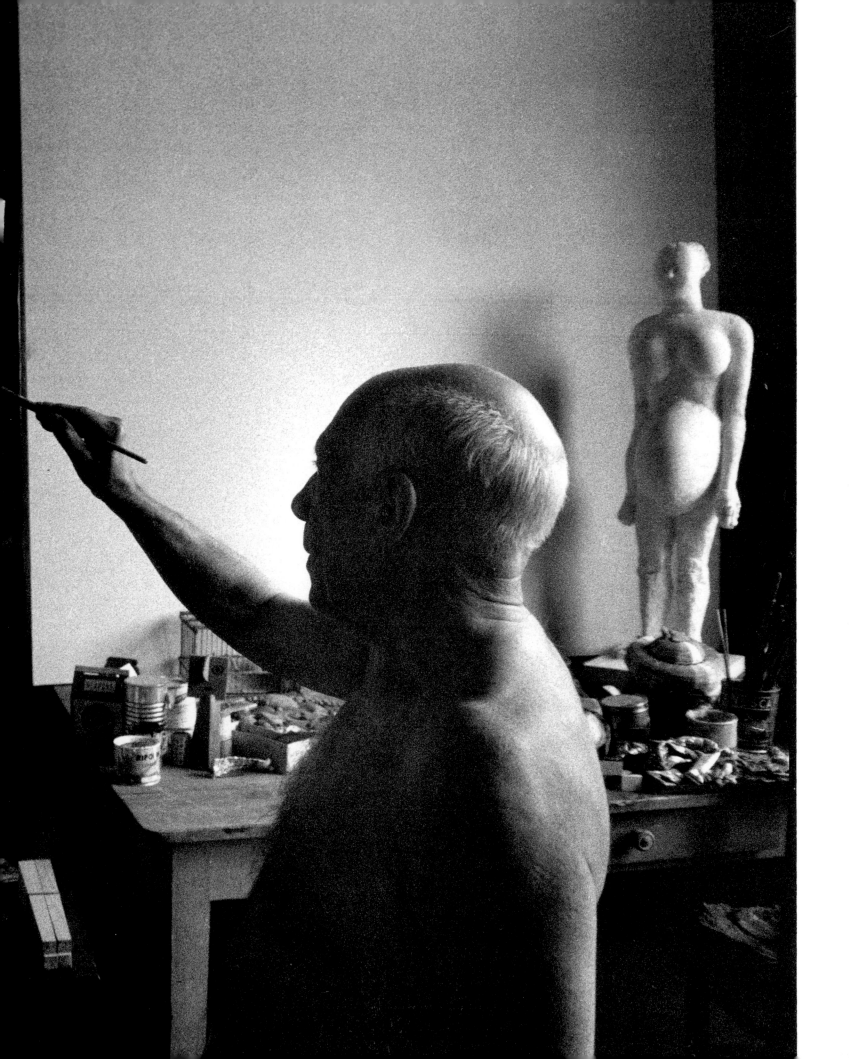

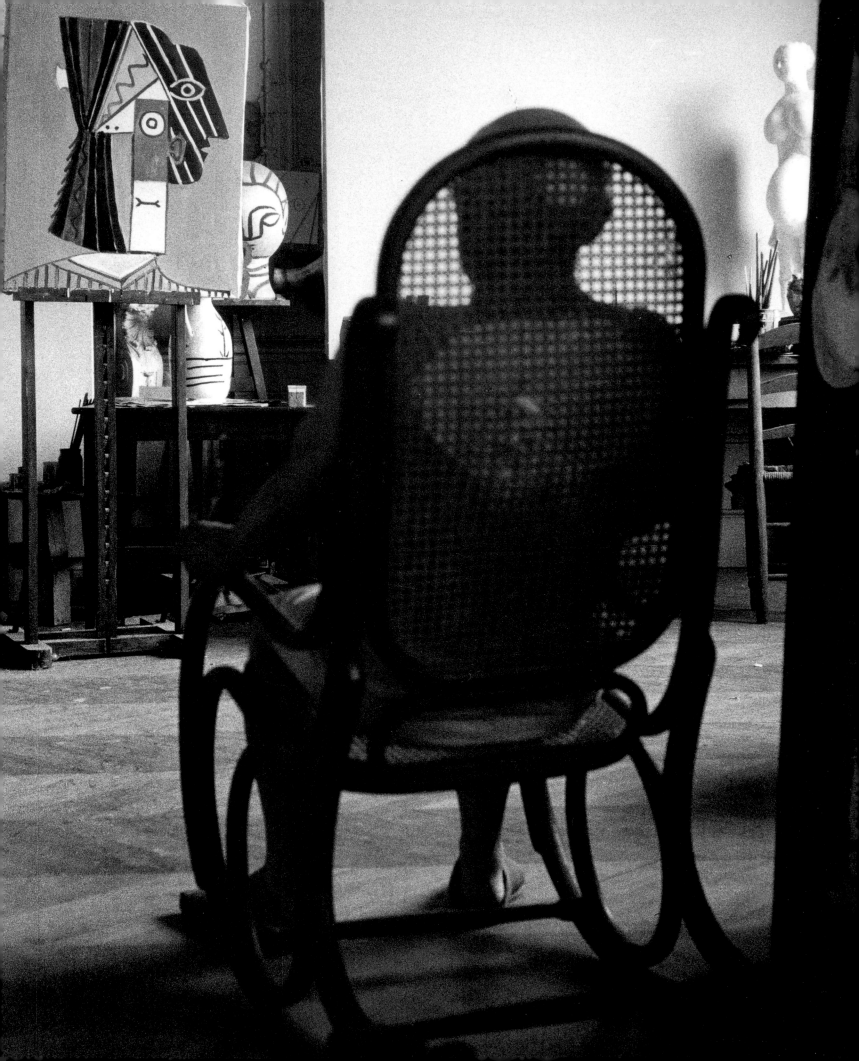

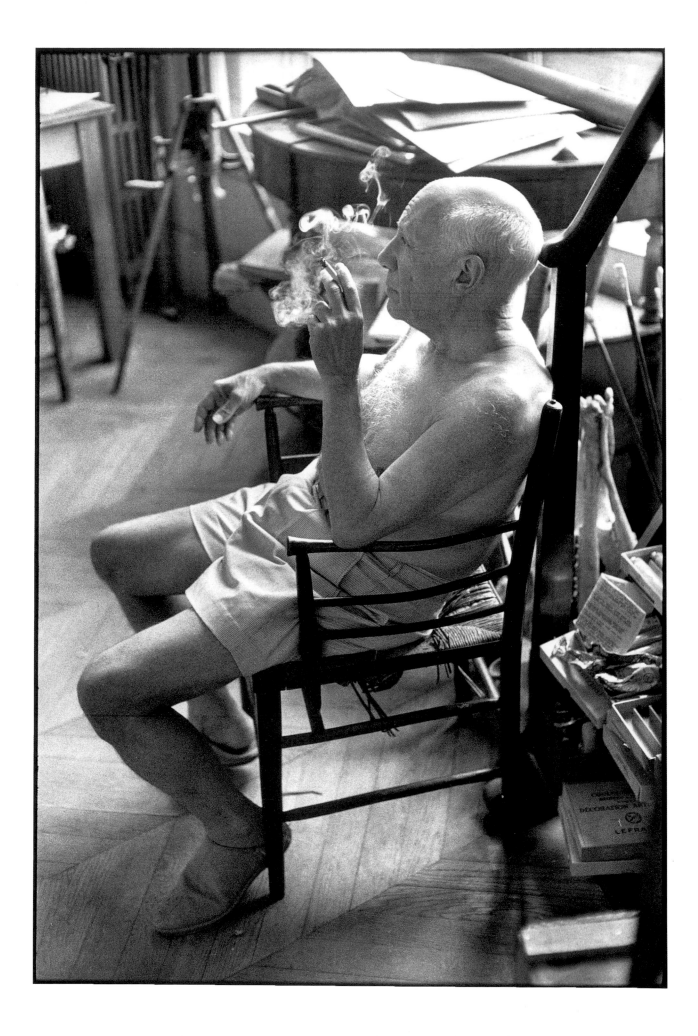

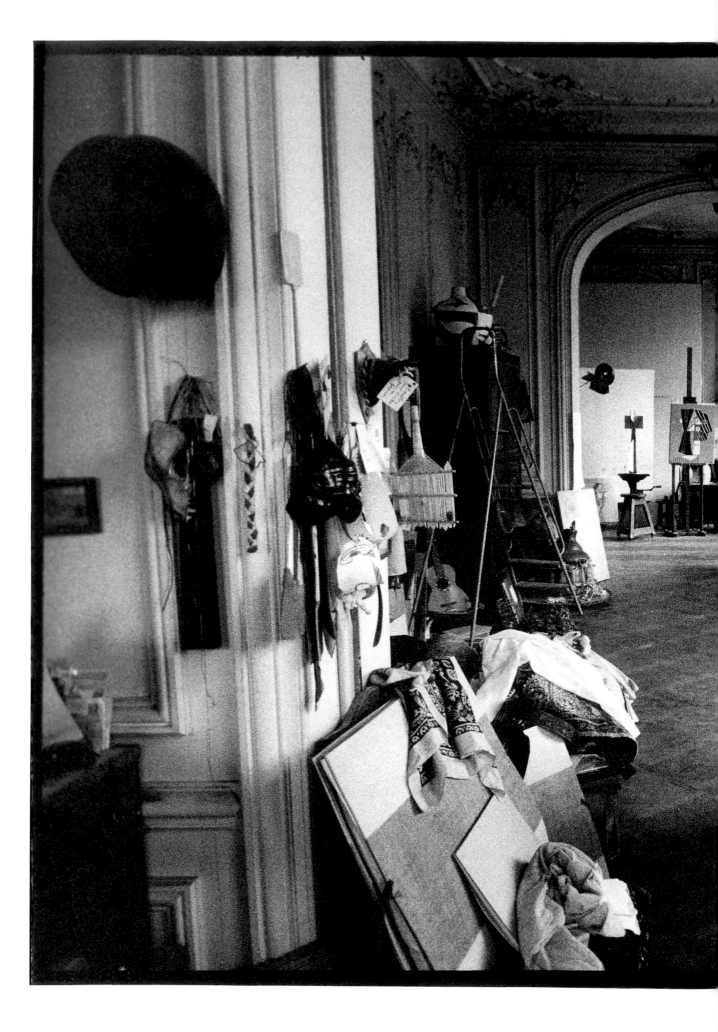

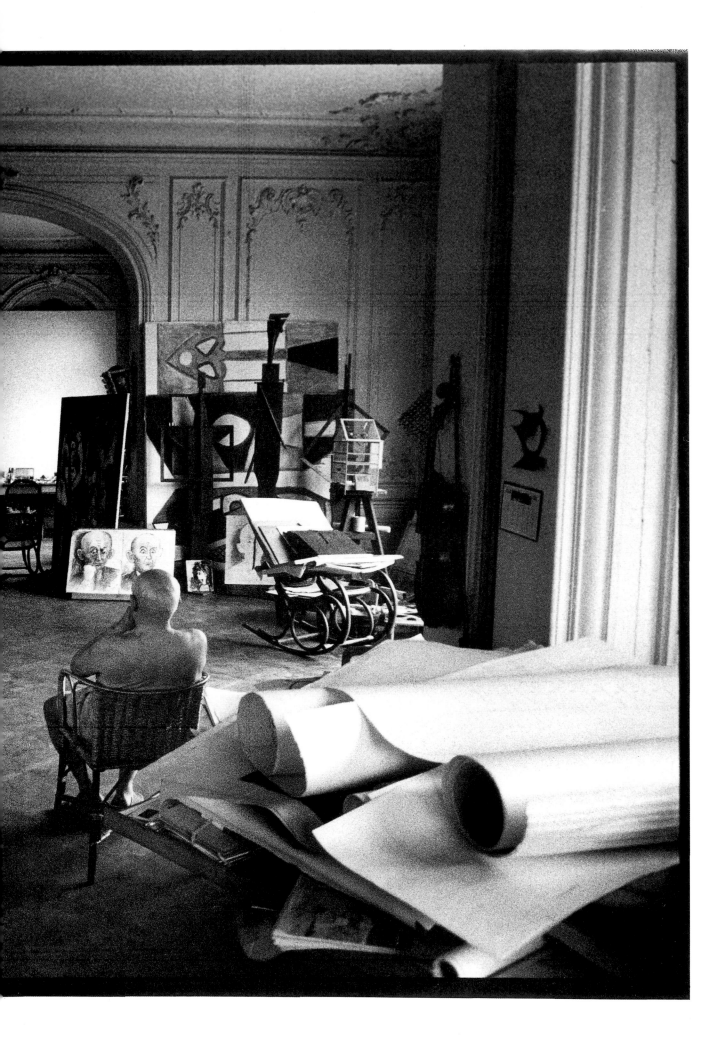

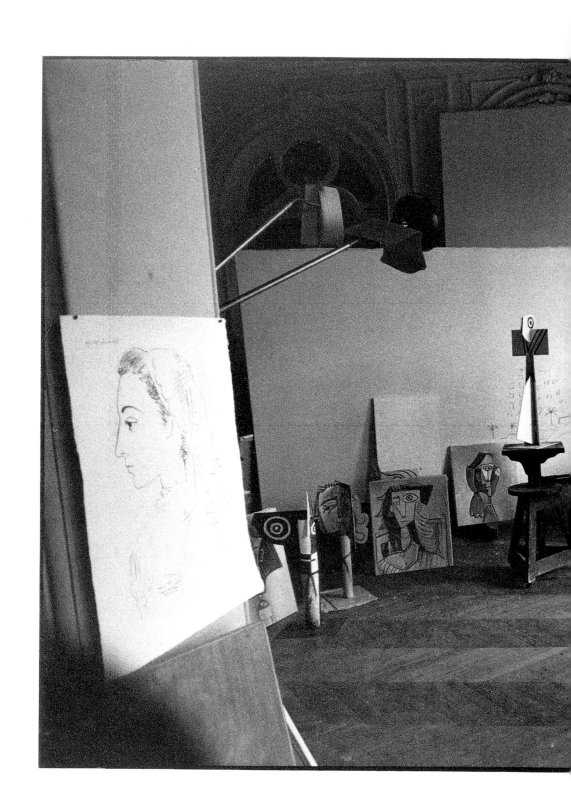

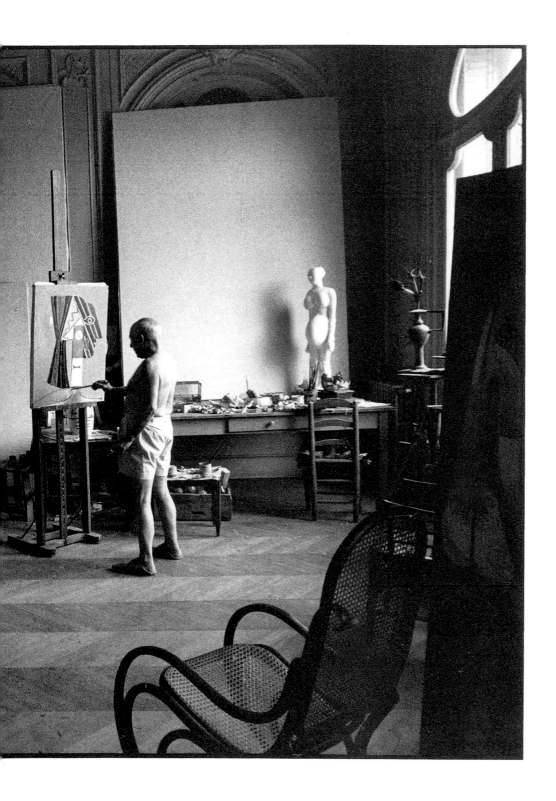

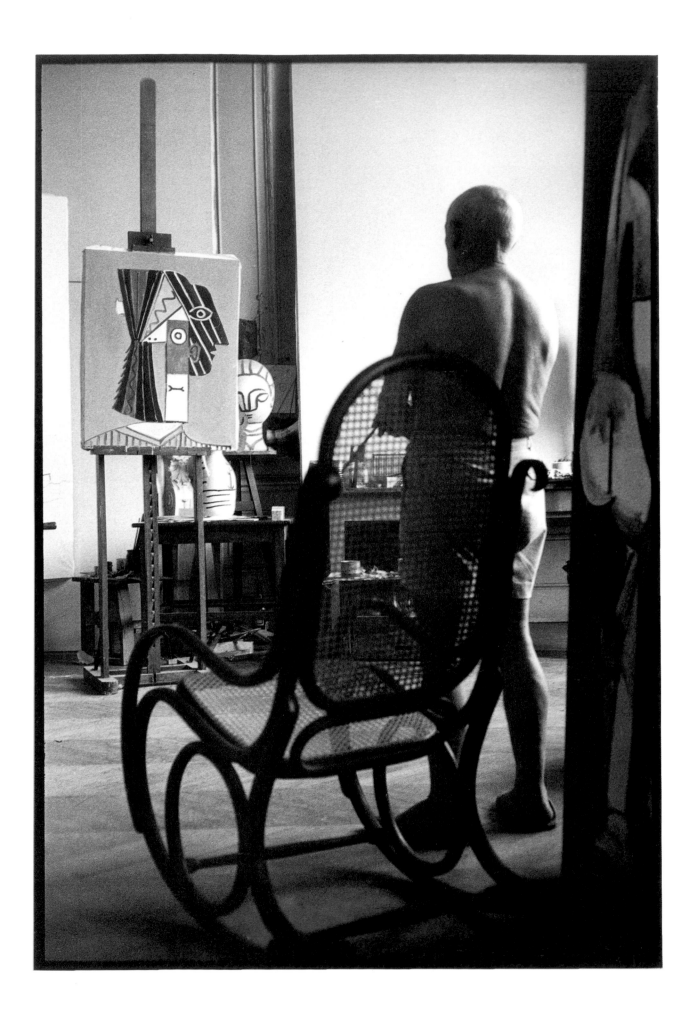

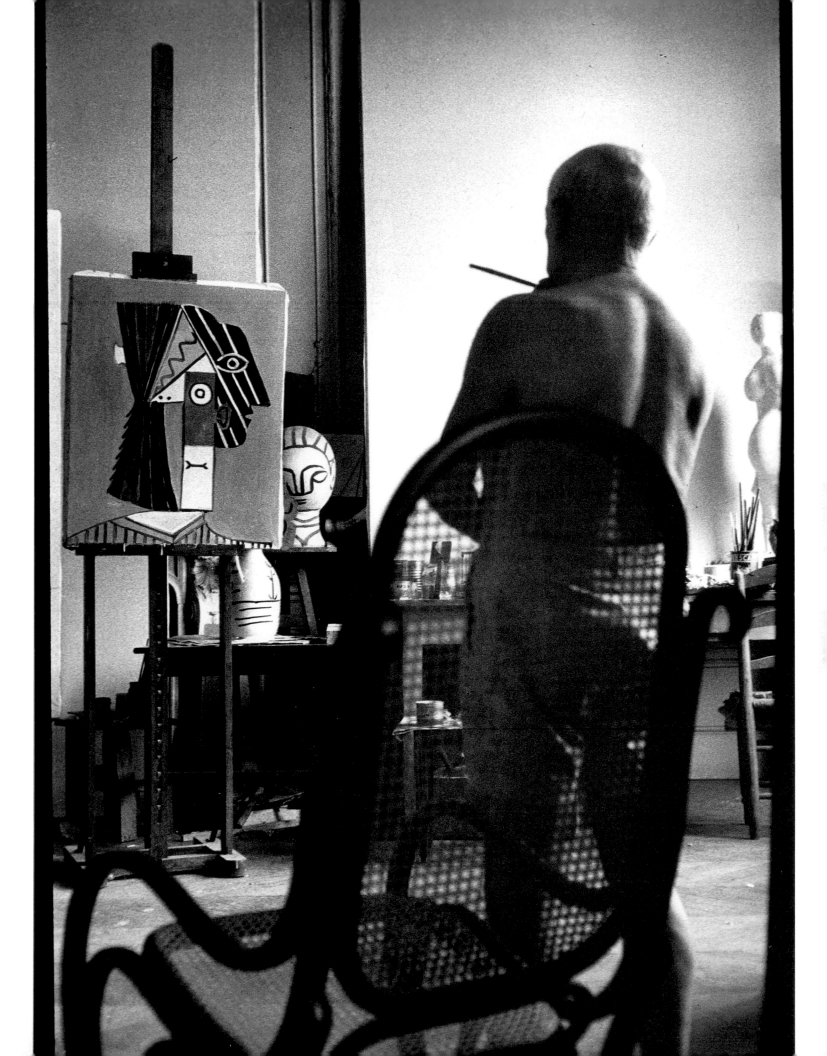

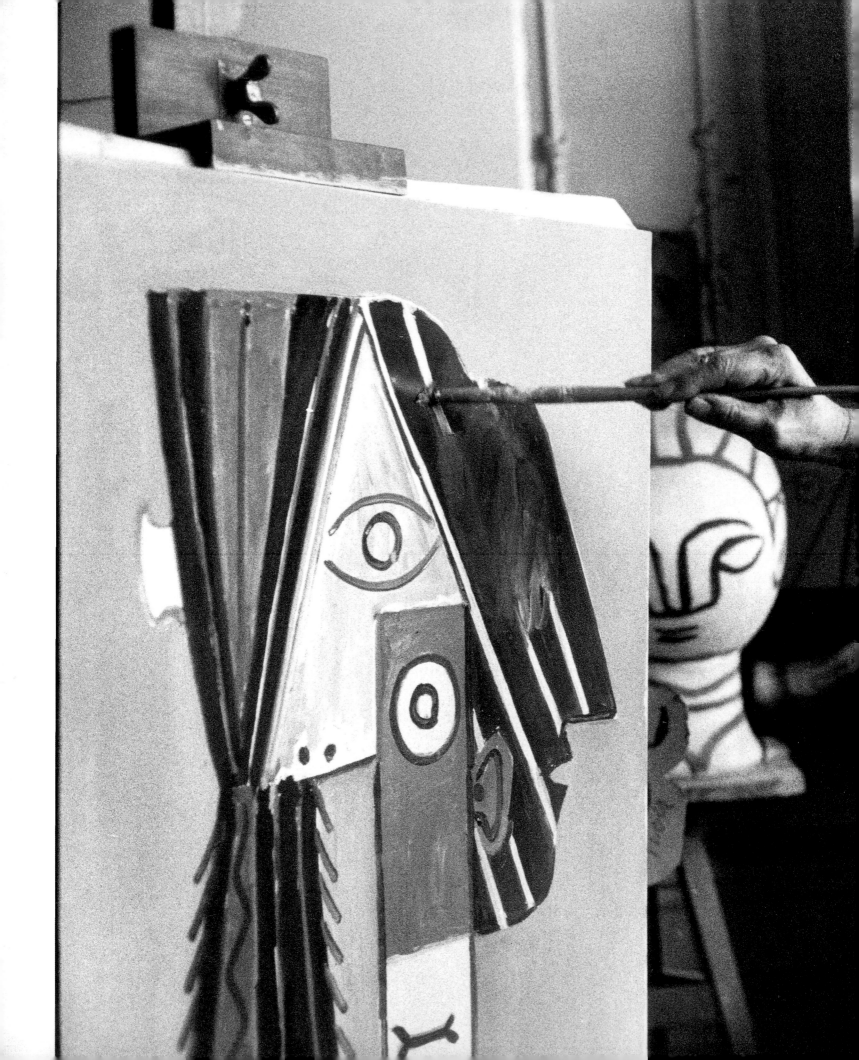

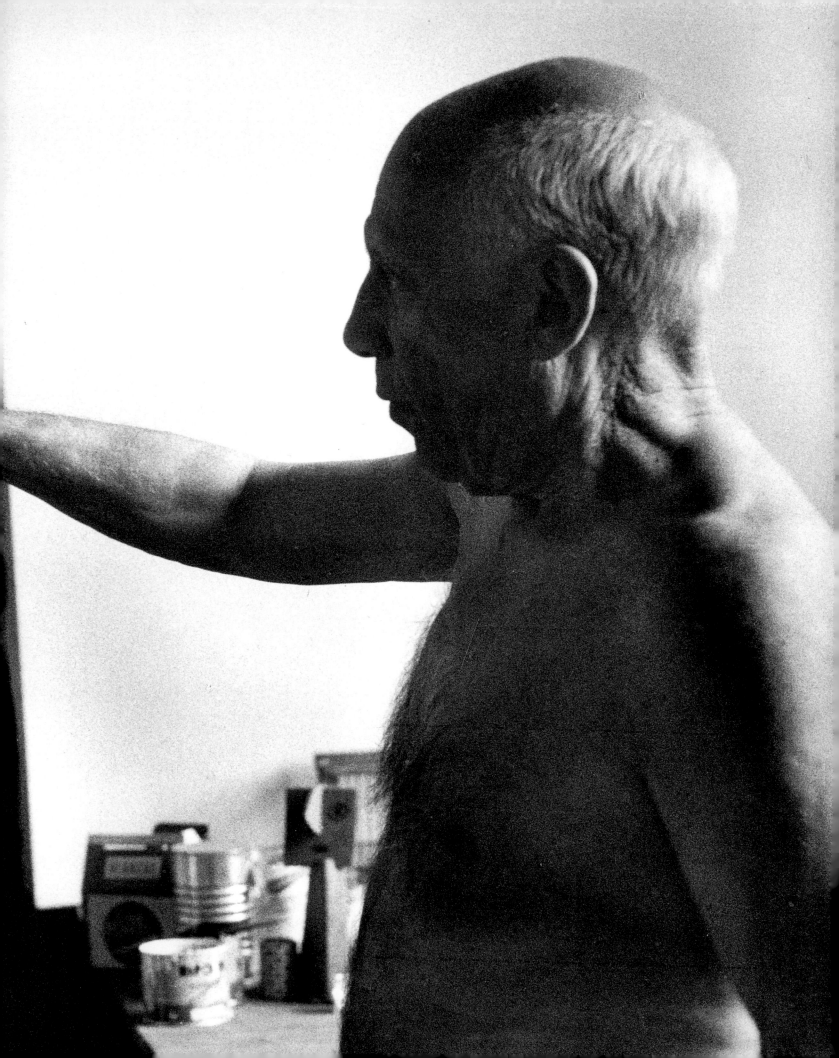

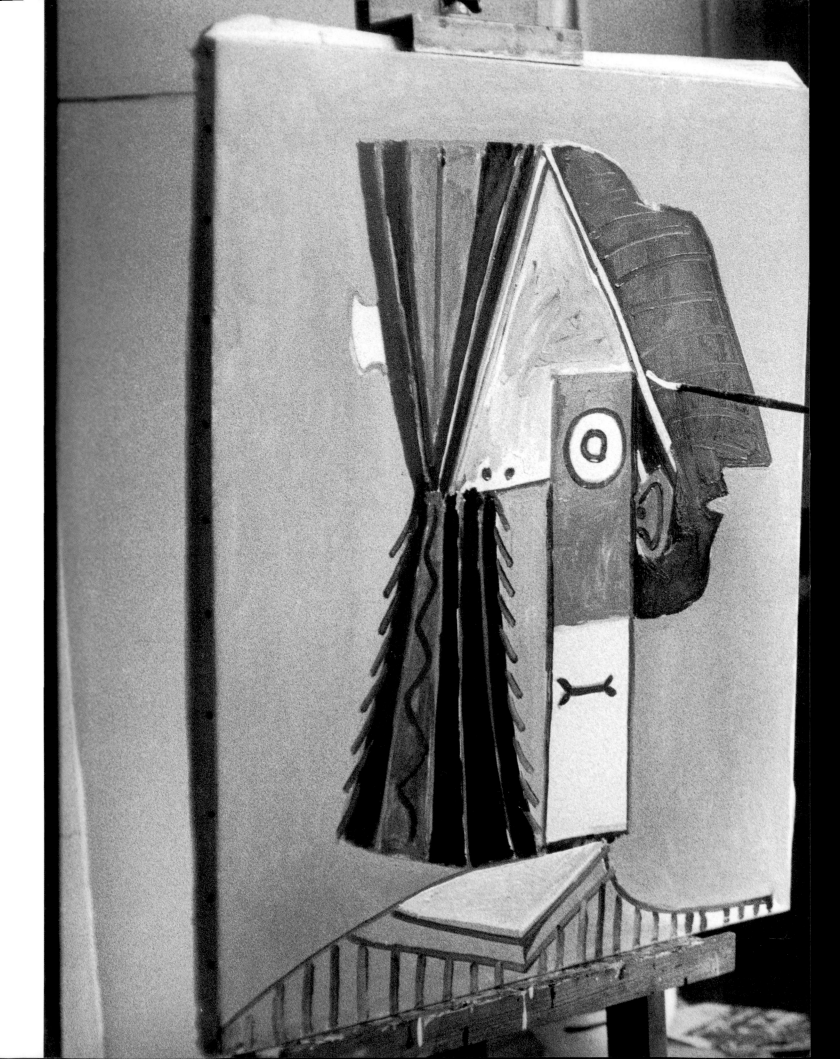

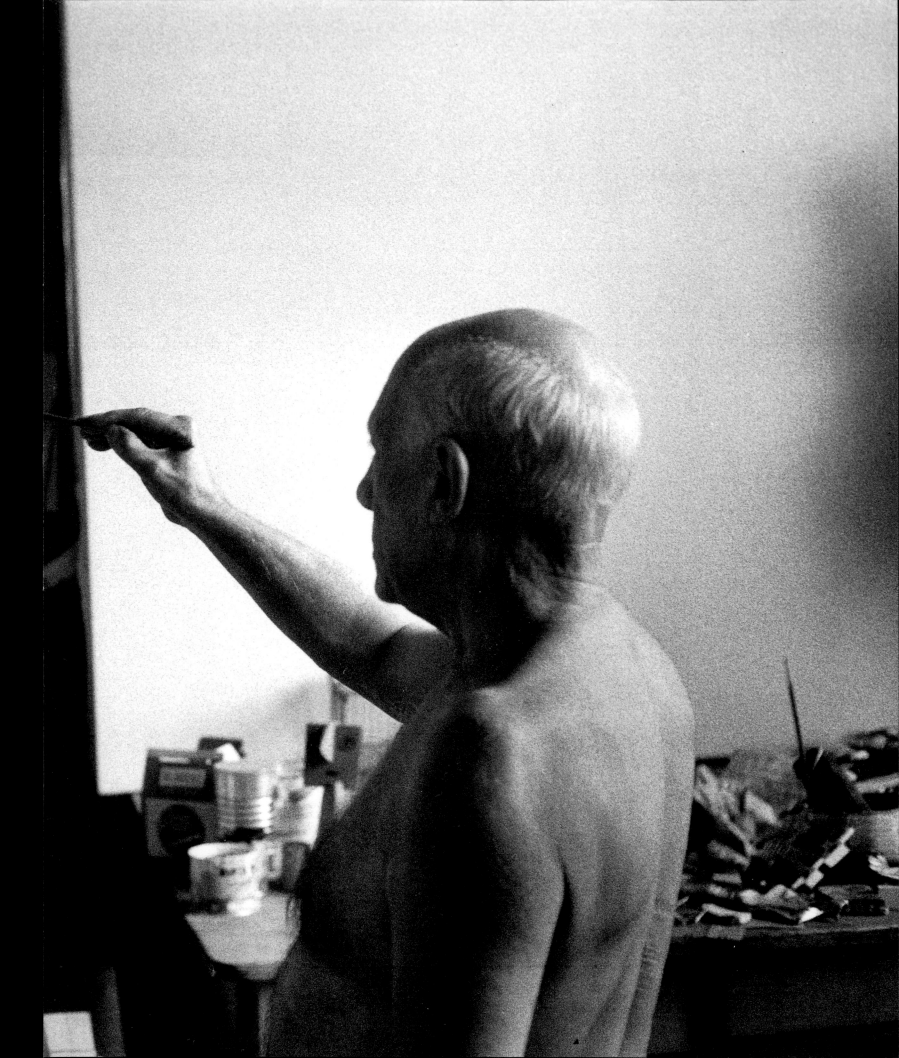

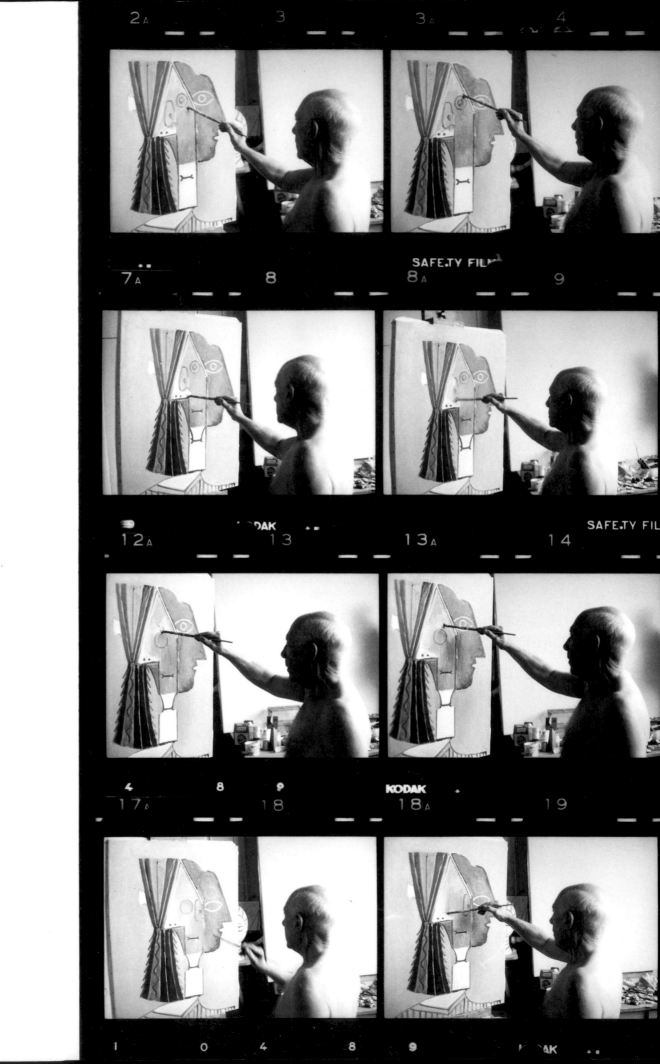

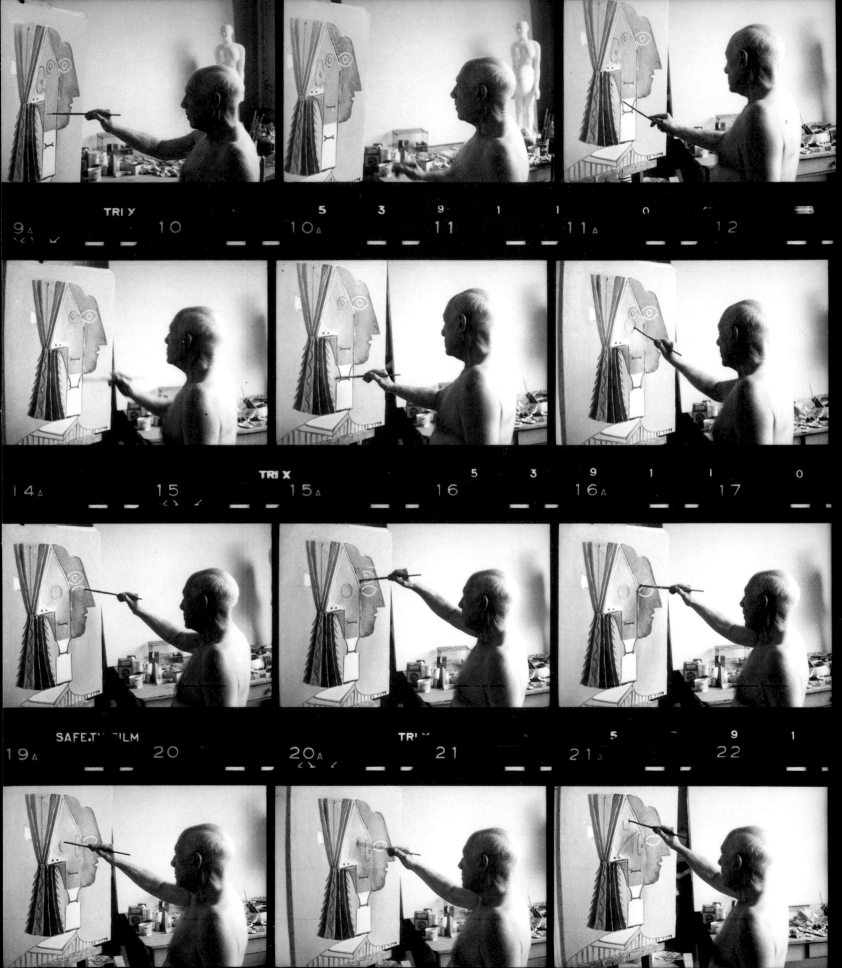

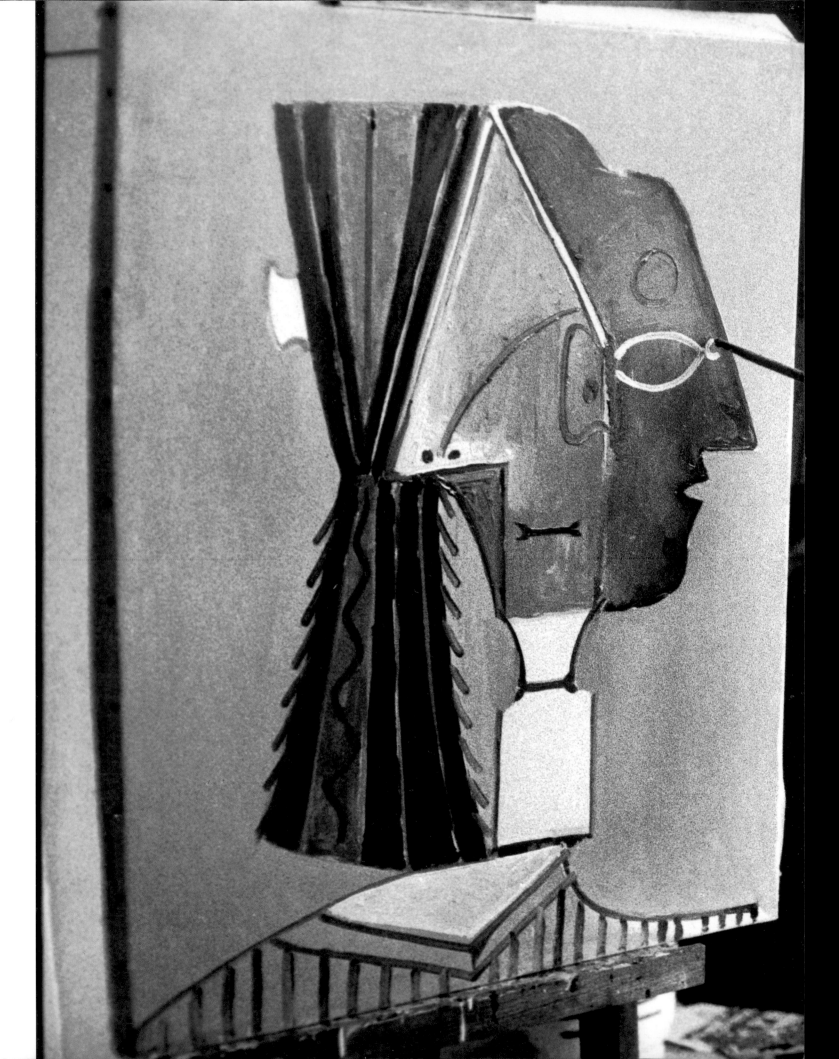

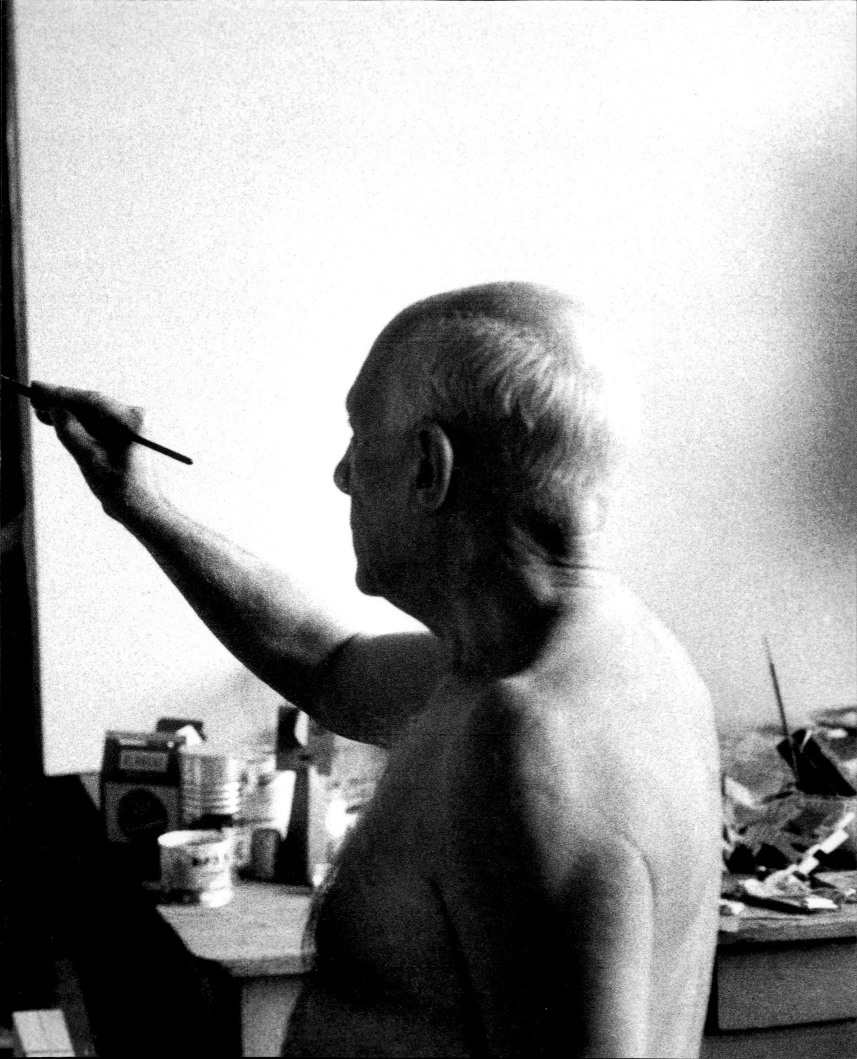

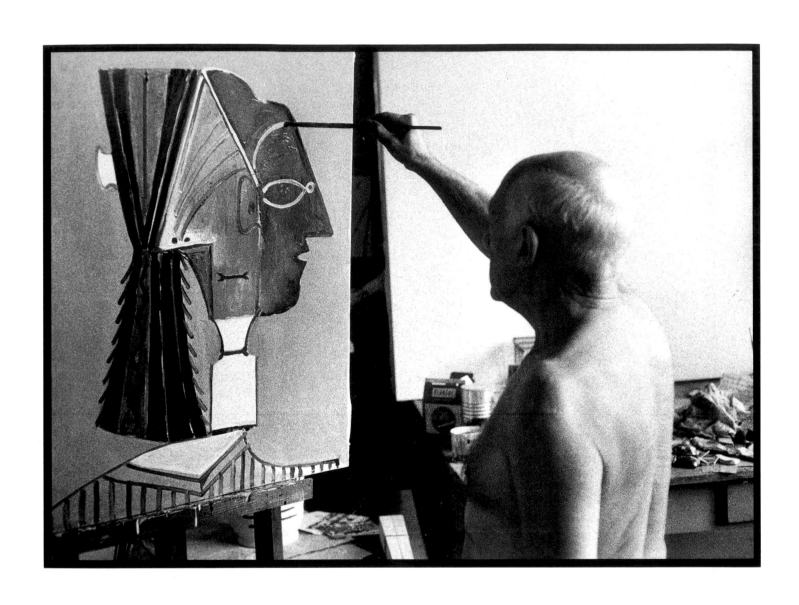

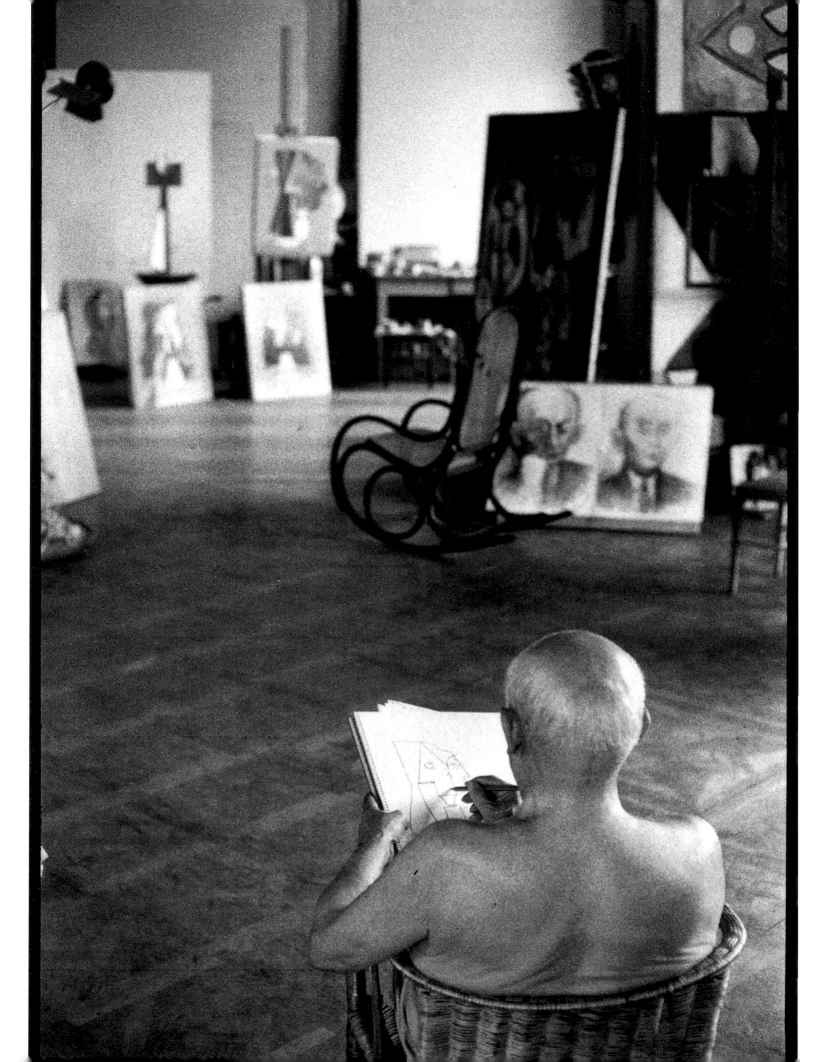

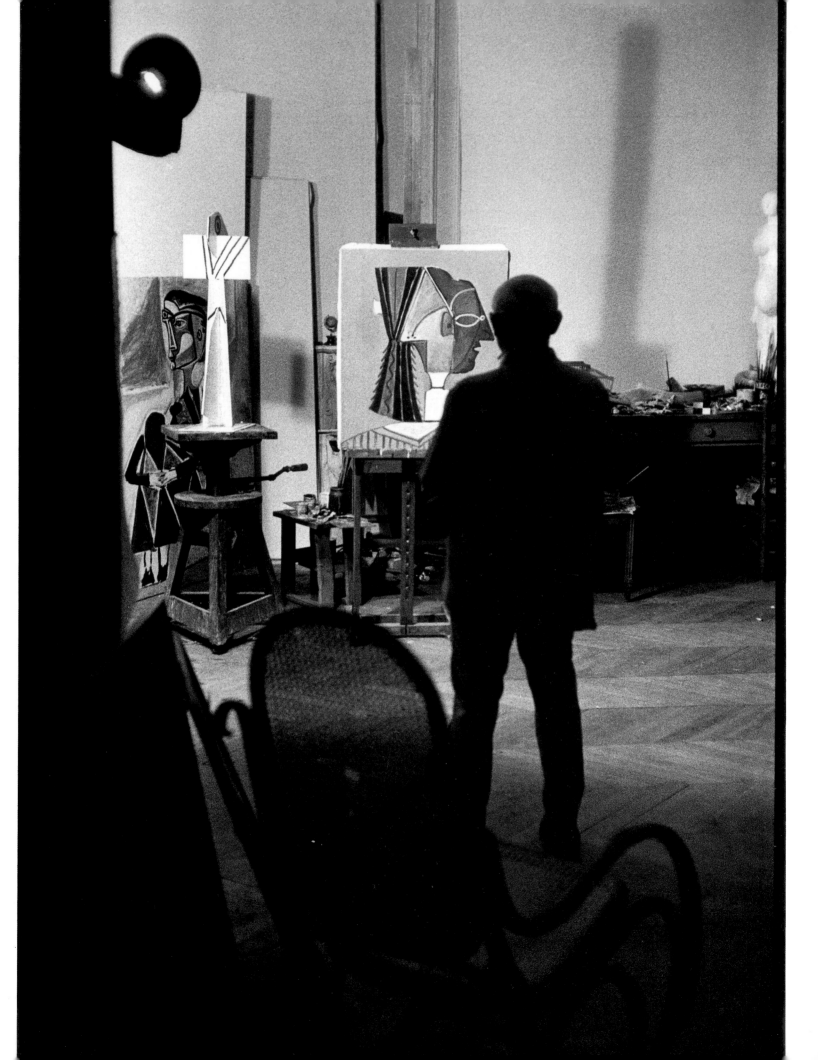

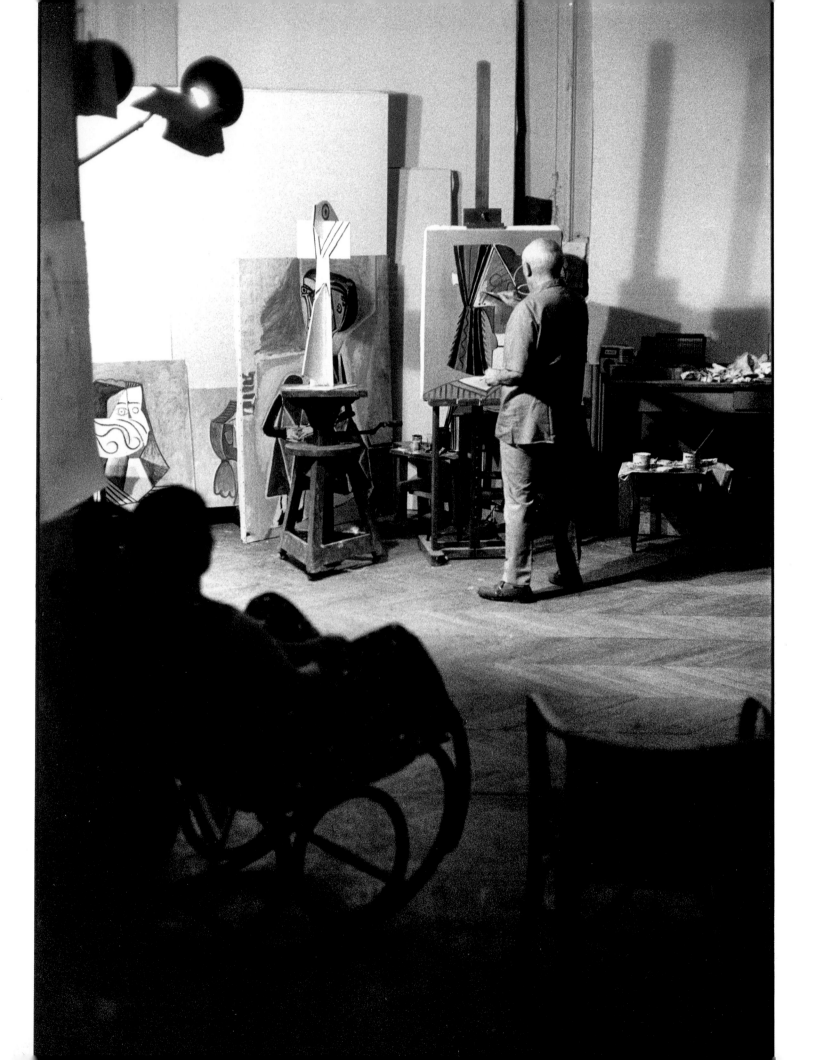

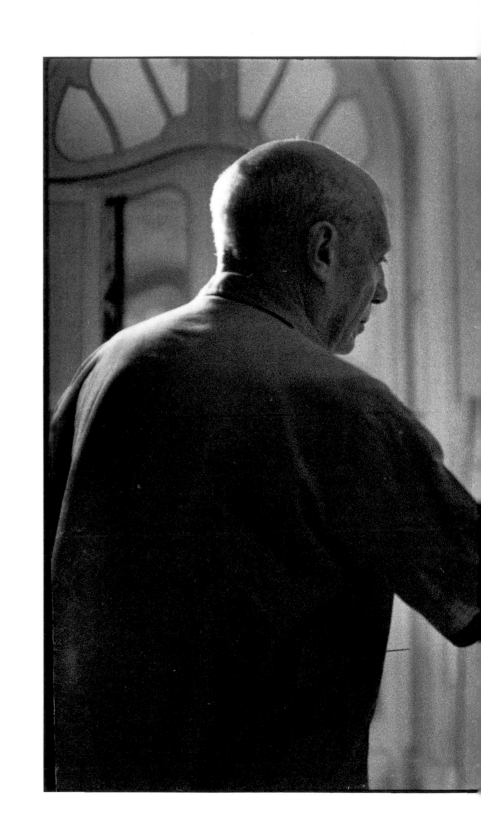

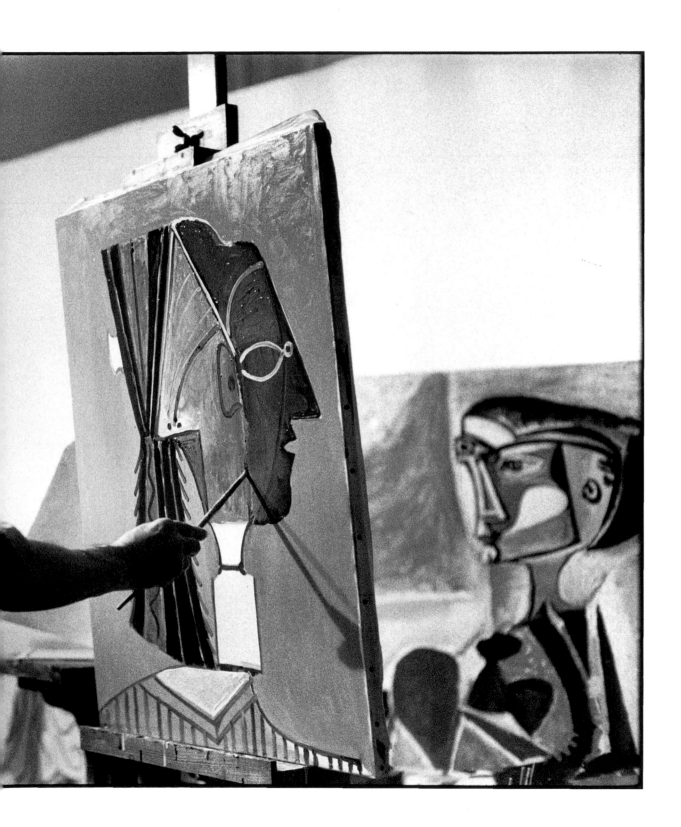

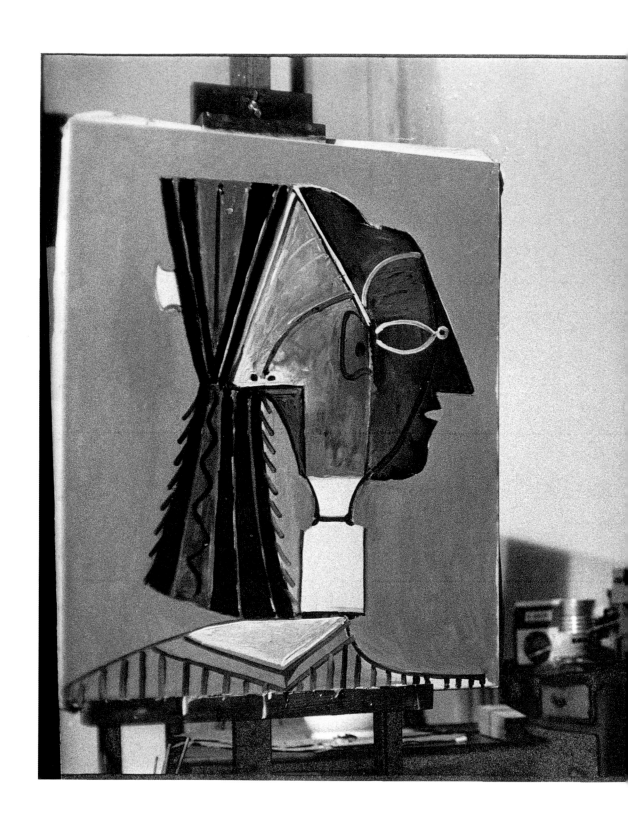

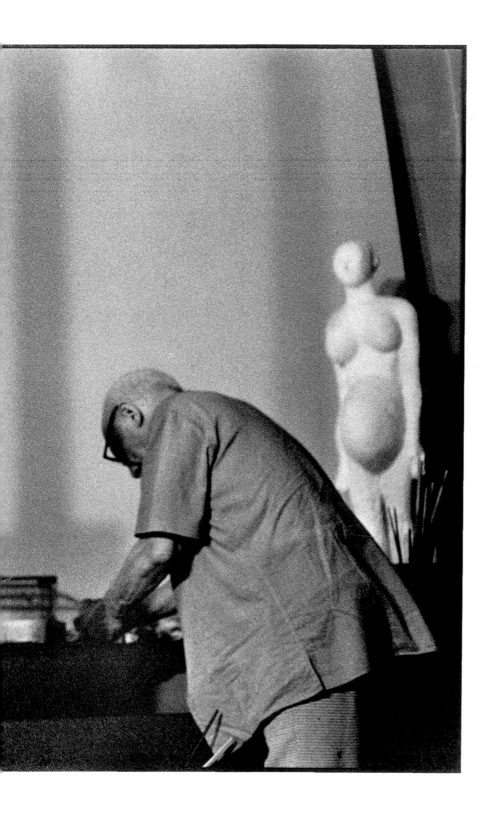

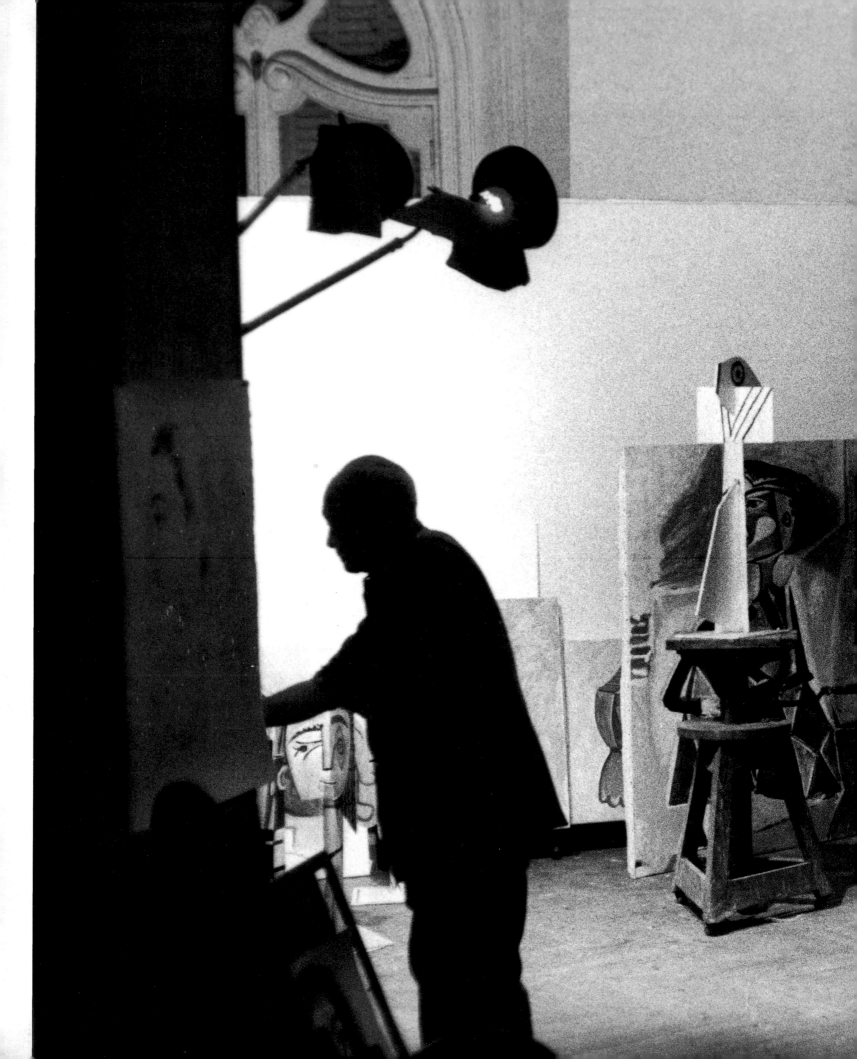

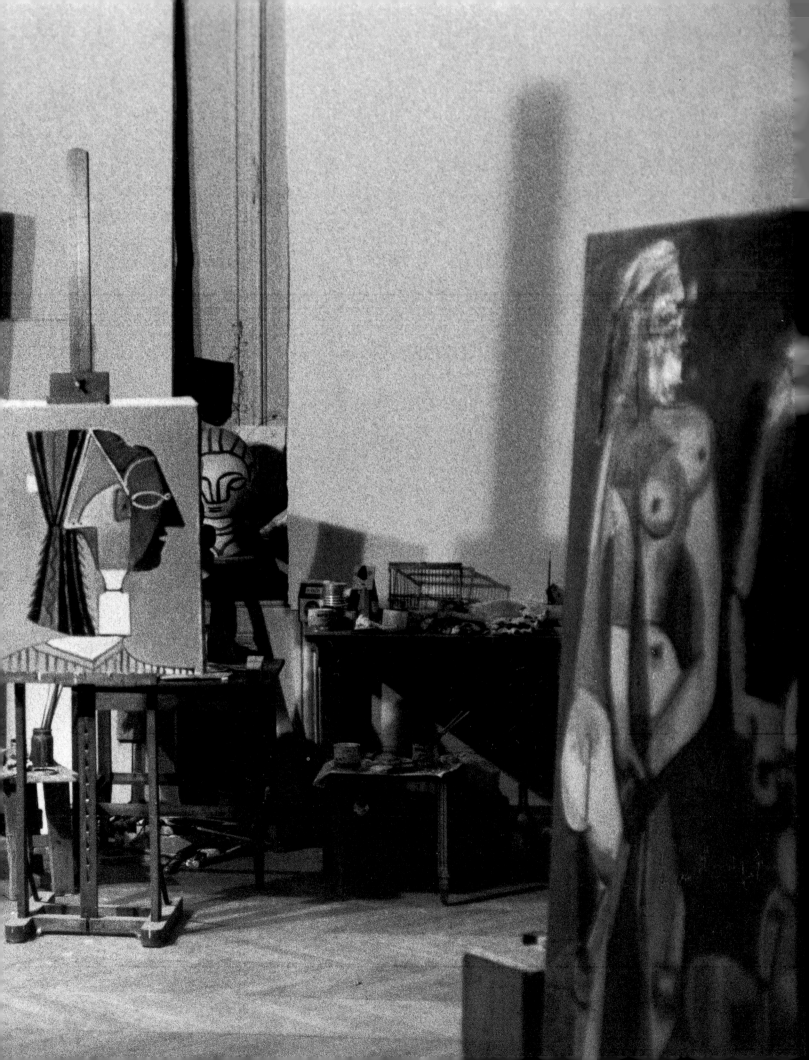

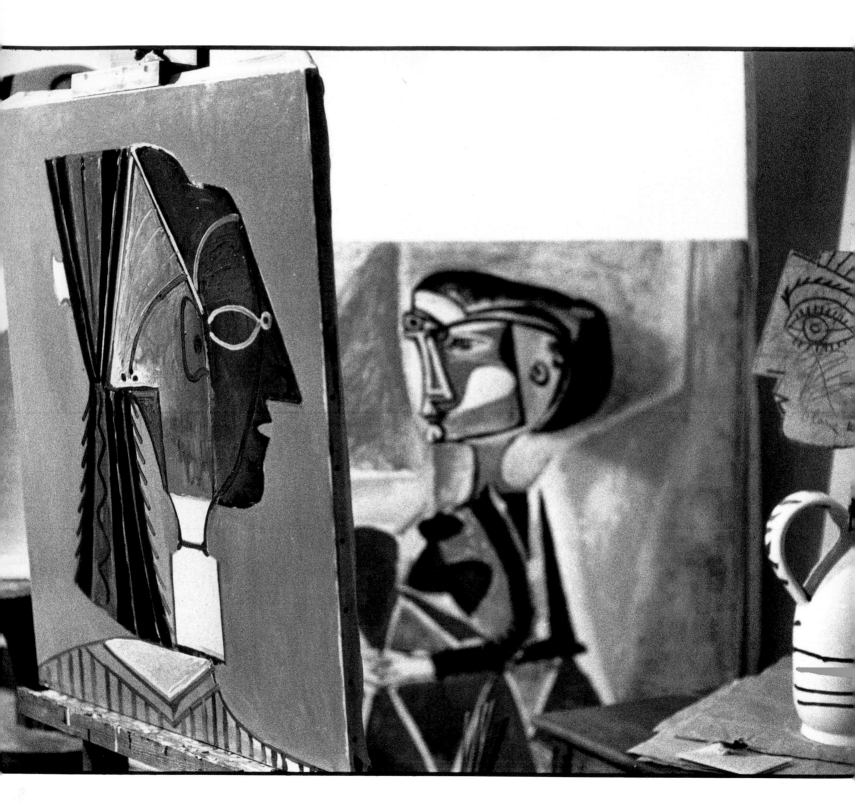

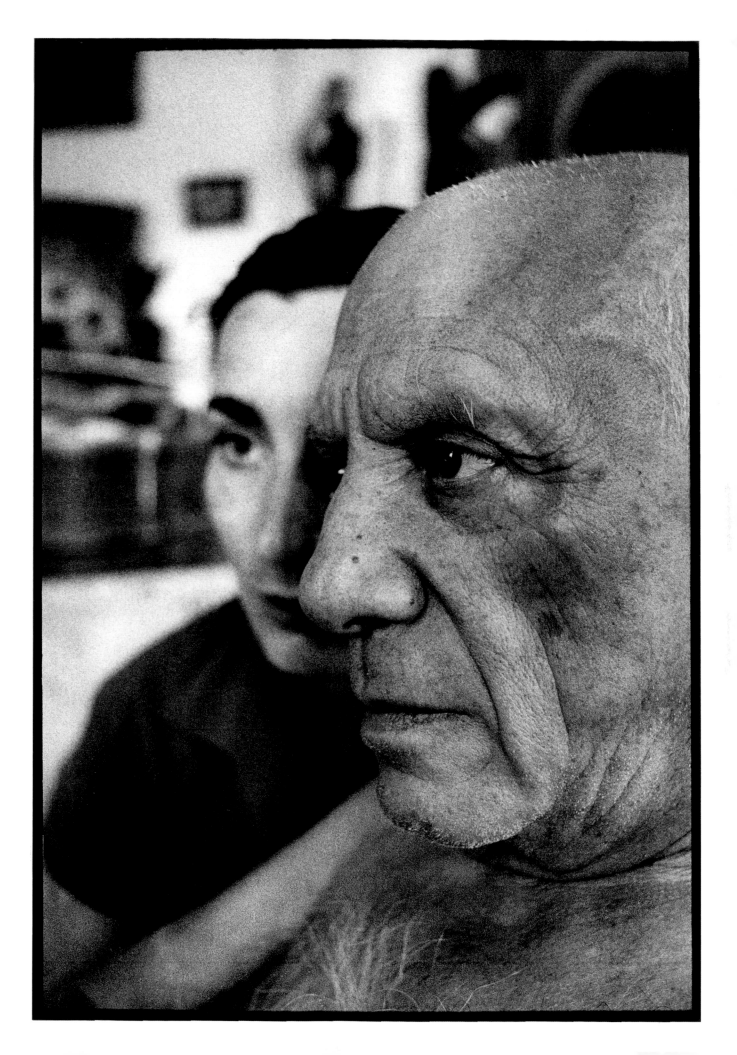

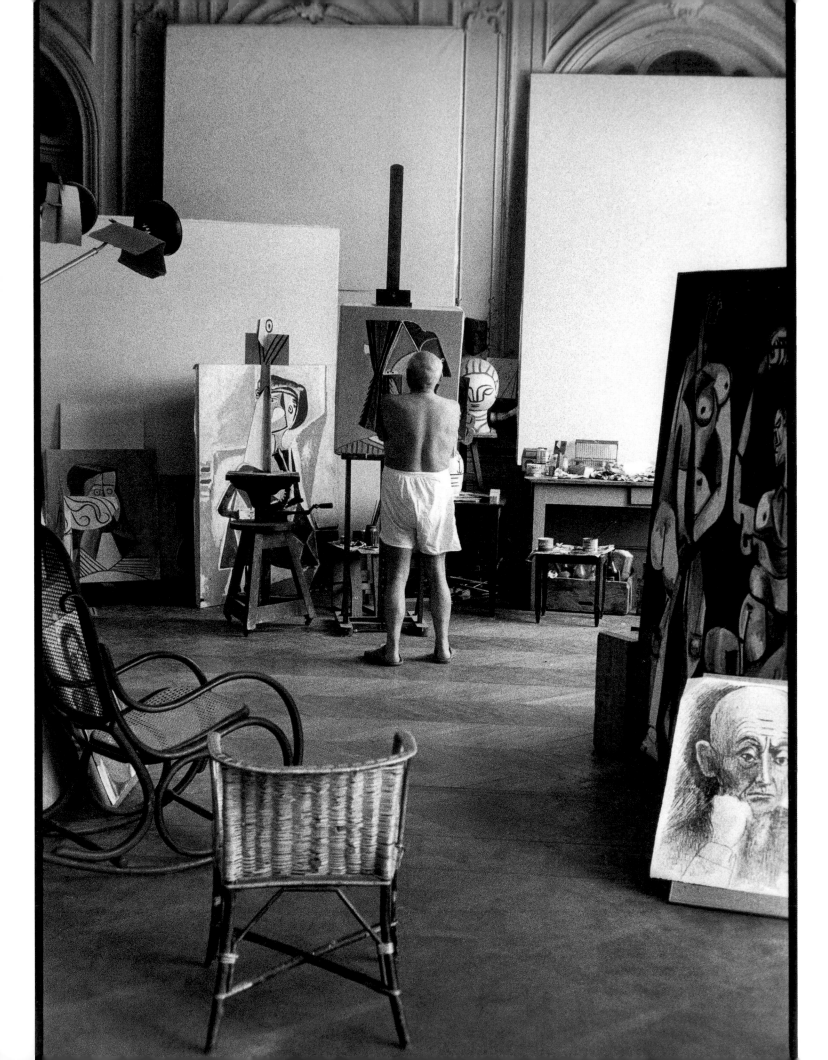

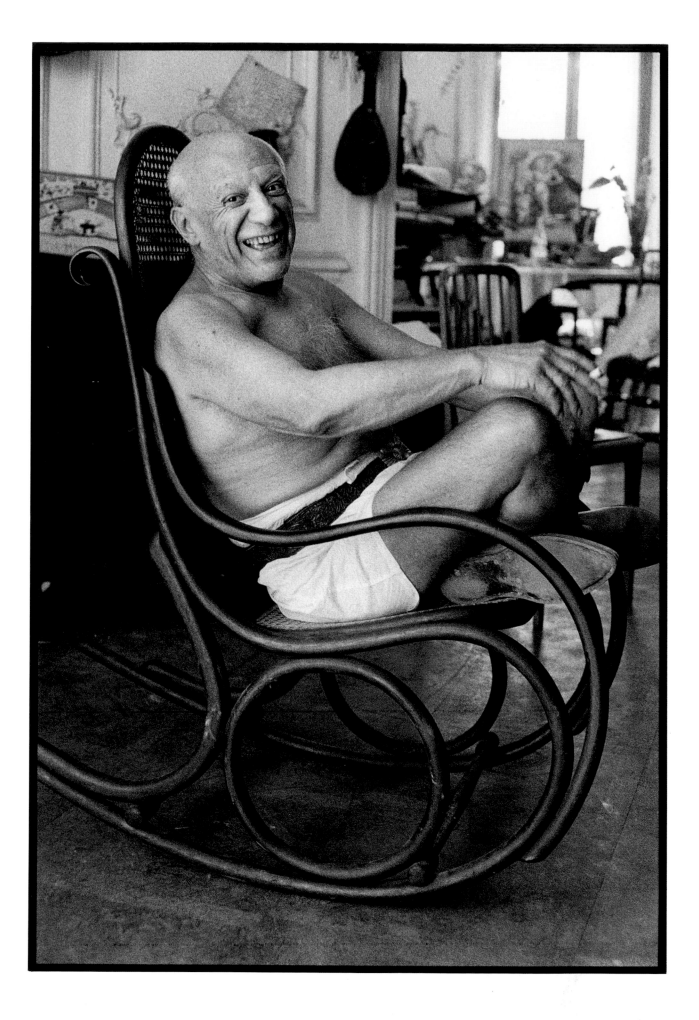

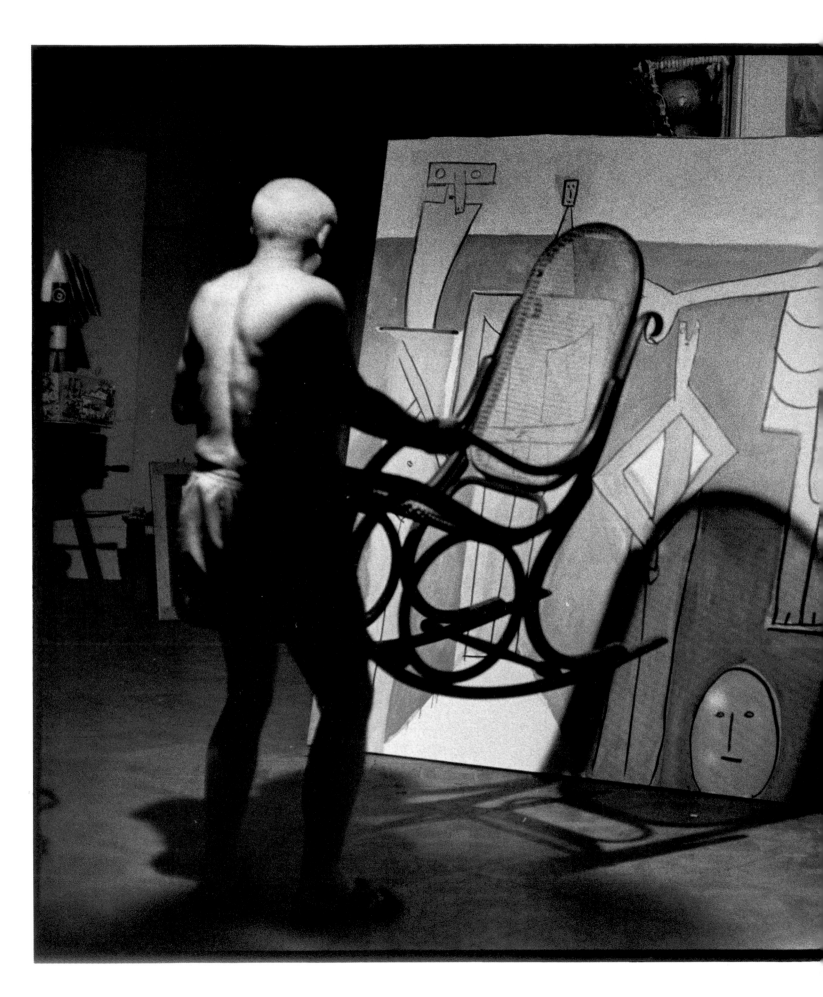

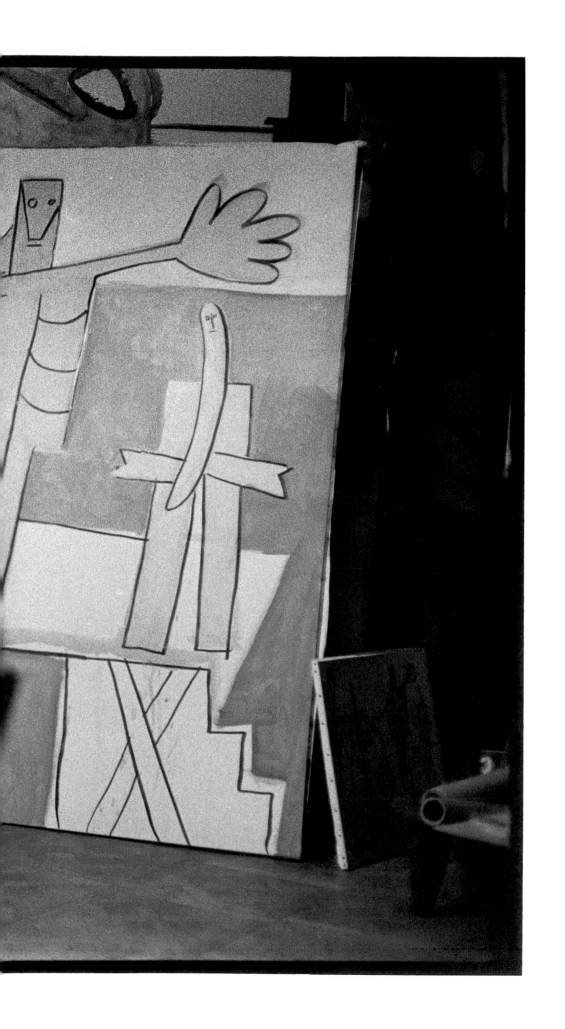

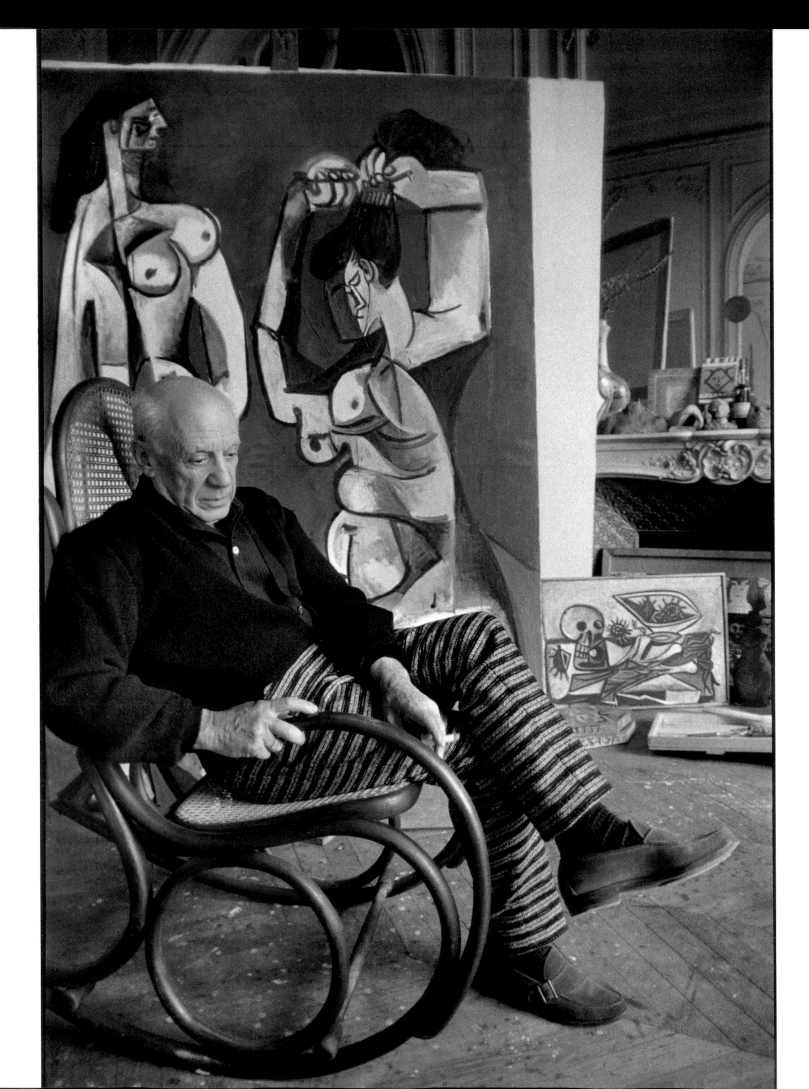

Starting Again

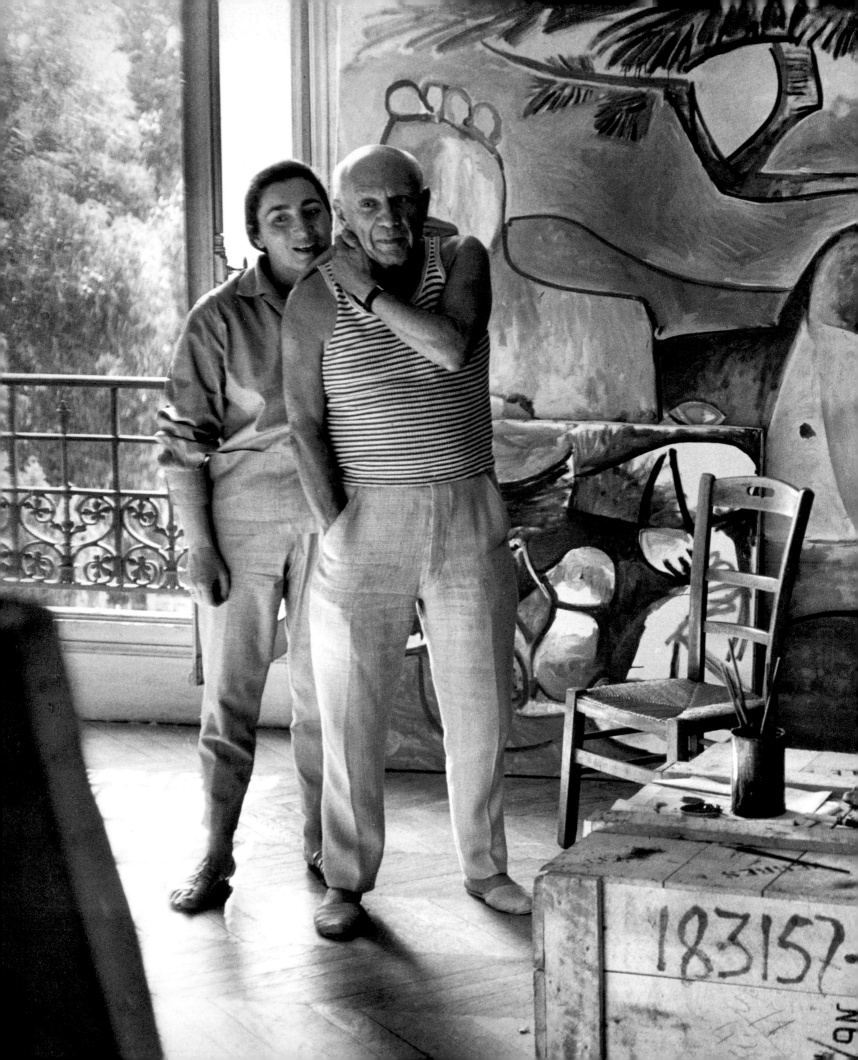

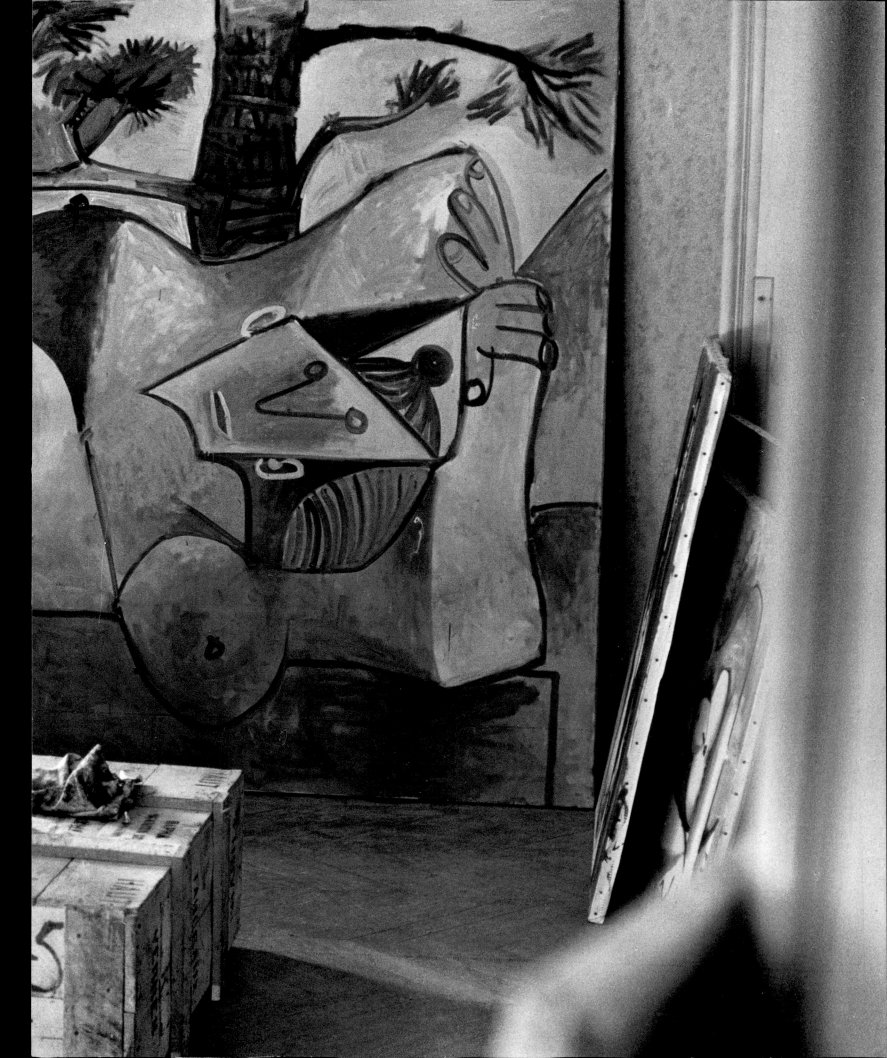

Dedicated
to
*Portrait of Jacqueline*
Page 43
Late afternoon of 1 July, 1957